THE SLAVES OF

Central Fairfield County

THE SLAVES OF

Central Fairfield COUNTY

THE JOURNEY FROM SLAVE TO FREEMAN IN NINETEENTH-CENTURY CONNECTICUT

DANIEL CRUSON

Charleston · London

History
PRESS

Published by The History Press
Charleston, SC 29403
www.historypress.net

Cover images: *Left*: The only known photo of a Newtown slave descendant, Alfred Jefferson Briscoe. *Right*: Jeff's panel on the left face of the monument, with a small fireman's helmet molded into the metal above. *Courtesy of the Newtown Image Archive of the Newtown Historical Society and the author.*

First published 2007

Manufactured in the United Kingdom

ISBN 978.1.59629.151.5

Cruson, Daniel.
The slaves of central Fairfield County: the journey from slave to freeman in nineteenth-century Connecticut / Daniel Cruson.
p. cm.
Includes bibliographical references.
ISBN-13: 978-1-59629-151-5 (alk. paper)
1. Slavery--Connecticut--Fairfield County--History. 2. Slaves--Connecticut--Fairfield County--Biography 3. Slaves--Connecticut--Fairfield County--Social life and customs. 4. African Americans--Connecticut--Fairfield County--Social life and customs. 5. African Americans--Connecticut--Fairfield County--Politics and government. 6. Fairfield County (Conn.)--Race relations. 7. Fairfield County (Conn.)--Rural conditions. 8. Fairfield County (Conn.)--Politics and government. 9. Antislavery movements--Connecticut--Fairfield County--History. 10. Underground railroad--Connecticut--Fairfield County.
I. Title.
E445.C7C78 2007
306.3'62097469--dc22
2006035481

Contents

Preface

One evening, while watching the end of the local news, I was suddenly surprised by the news item that was meant to end the program on an entertaining note. A young student was standing in front of one of Yale's oldest buildings, on which she had been doing some historical research. She had a shocked expression as she explained her discovery that the founder of the university, Elihu Yale, had been a slave owner. "How," she asked, "could an influential clergyman in the Northern state of Connecticut have owned slaves?"

My surprise was even greater than hers. As an experienced local historian I had known that slavery was as prevalent here in the North as it had been in the South, although it was practiced by many fewer individuals. The wealthy and most influential men in most Northern towns were the ones who could afford slaves, although even those of modest means sometimes had a slave as a domestic servant or field hand.

As I mentioned the local news item to friends and some colleagues, I rapidly became aware that ignorance of Northern slavery was widespread. Being a teacher all of my life, I have always felt the pressing need to dispel ignorance in any of its forms. This book is the product of that compulsion.

I quickly made the decision to focus on a small area, which would allow me to master all of the information about slaves and free blacks that was available, something that could not be done with the information from the entire state or even a large city. As I am the town historian for Newtown, it seemed logical to confine myself to this town and the immediately surrounding towns of Redding, Weston and Easton, three towns in which I had worked and lived before coming to Newtown. This, then, is to be a study in rural Northern slavery, something that has not been extensively written about before. In fact, aside from a few vignettes in local histories, rural slavery in Connecticut has not been dealt with at all.

PREFACE

The primary task became to find out how large the slave population of the Newtown area was and to see how many of these slaves could be identified. With the discovery of emancipation documents in the land records, I realized that the identification of Newtown's slaves was a real possibility and that it might be possible, using other town records, to recover information on the social, economic and religious life of Africans during their period of enslavement and also after manumission.

As the project began to take on a life of its own, it quickly grew far larger than originally intended, leading to an exhaustive search of all town public records as well as those of the towns' churches. In addition, state resources, including the state archives and the Connecticut Historical Society, were searched and at this point I am confident that, aside from some as yet undiscovered personal papers, all data that exists on the slave and free black population of Newtown and its surrounding towns has been located. From this data come some new and sometimes startling insights into Northern slavery. It has also become apparent that the institution of slavery in the North was strikingly different from its counterpart in the South.

Introduction

The Problem

S outhern slavery, often called the "peculiar institution," is probably the most studied of America's historical social institutions. Slavery was also practiced in the North, but interest in it has been almost totally eclipsed by that in the South. There are several reasons for this, but the most significant one is the lack of information on Northern slavery. This dearth of information may be traced to three factors: slavery in the North ended several decades before it did in the South; it involved many fewer blacks; and it was less important as an institution here than elsewhere. Northern slavery simply did not generate the large volume of statistics that attract econometricians and social historians.

Although slavery in Connecticut was not formally abolished until 1848, its practice had effectively died out almost half a century before Southern slaves were formally emancipated. In the South, it was possible to actually interview former slaves as late as the 1930s, when the WPA compiled its voluminous oral history, *The Slave Narratives*. A similar oral record of Connecticut slavery was impossible. When this state's former slaves were in their dotage, slavery was still practiced in the South, so there was no interest in recording the memories of Northern blacks. By the twentieth century, when historians finally became interested, former slaves were fairly plentiful in the Southern states, but the last slave in the North was long dead.

Another major obstacle facing researchers of Northern slavery is the lack of statistical data on slaves and early free blacks. In the South, slavery was an important part of the business of large-scale agriculture. Slaves were capital investments and owners with pools of slave labor numbering from fifty to over five hundred kept careful records. Therefore, plantation accounts give a fairly good picture of prices of slaves, costs of feeding and clothing, medical expenses and even vital records of births, marriages and deaths. Because they were valuable property, the massive slave market of New Orleans also kept records of slave sales.

None of these records exist in the North. Since slavery here was on a much smaller scale, slaves were not regarded with the same business perspective as in the South. Most Northern slaveholders had only one or two slaves. The largest slave owner that we know of in Newtown, for example, had only seven, and in Redding Colonel John Read had ten, but eight of these were of one family. As a result, Northern slaves were considered in a similar manner as were hired hands or personal servants in later periods. Hired hands and servants generate very few records. In addition, free black families were almost always in the lower socioeconomic ranks of early Connecticut society and these classes, regardless of race, produce very few records. The subconscious racism that characterized Connecticut, as well as most other states in the nineteenth century, also ensured that free black families were ignored, with a few notable exceptions.

Given these impediments to a statistical study of slavery in the North, any study of Northern slavery is of necessity confined to anecdotal data and what vital data can be found in the official town records, probate records, church records and, in the case of free blacks, the town's land records and federal census documents. From this information, a profile of slaves and early free blacks has been built up that gives us a clearer, though still foggy, picture of African Americans in the rural North.

The decision to limit the study to the towns of Newtown and its immediate neighbors was made because in the late eighteenth and early nineteenth centuries they were fairly typical rural Connecticut towns, each with a population large enough to generate a reasonable, if limited, amount of information on its African population. The period of this study extends from the earliest mention of slaves and free blacks to the year 1860. That was the last census year before the Civil War, so it was the last year that would allow eventual comparison to the African situation in the South while slavery was still practiced and before the trauma of forced emancipation.

The most important source of information on slaves turned out to be emancipation documents. For most of the towns under study, when slaves were formally emancipated after 1791, the emancipation documents were recorded by the town clerk in the land record volumes. To date, twenty-one of these have been found for Newtown alone and they supply the slave's name, the name of his master, at least a rough estimate of his age and occasionally other data such as the mother's name and her status as a slave. (This was needed to establish the subject's status as a slave, since that status descended through the mother.) Regrettably, the town clerk of Redding in the late eighteenth century did not take the 1791 law seriously, and there are no emancipation documents for that town.

The next most important source was the town's vital records of births, marriages and deaths. Although this data was casually collected on the black population, whenever it was recorded there was usually a notation that the record was for a "Negro." This made it easy to separate black records from those of the white population, a task that potentially could have been difficult since freed slaves frequently assumed their former master's last name and thus were indistinguishable from a white family on the basis of name alone.

In addition to these records, church records, census data, probate records, document collections in Newtown's Cyrenius H. Booth Library, local historical societies and the state archives were all carefully searched. These yielded scraps of information that usually supplemented the primary sources and sometimes supplied insights that the raw vital records could not.

Unfortunately, no narrative documents such as letters or diaries have been located. This was not entirely unexpected. Although in the North there were no laws forbidding teaching slaves to read and write, the Northern slave population appears to have remained predominantly illiterate. The number of early free blacks who had to "make their mark" on documents rather than sign their name suggests that the largest portion of the Newtown slave and early free black population would have been able to give only an oral history of their life.

Data has been found on almost five hundred slaves and free blacks who were imported into central Fairfield County or were born here. For many of these individuals, the database records are partial, giving a birth or death date or even a marriage date but little else. For others, the vital data was relatively complete, and in three or four cases families could be traced from slavery through emancipation for three or four generations before reaching the cutoff dates. These cases seemed to be typical and they give us the case studies that can help flesh out the raw statistical and anecdotal material.

On the whole, enough material has been found to give a satisfactory picture of the small black population of rural Fairfield County from its beginnings in slavery to their status as freemen and women. It shows the free black population as it existed both in the poverty of being hired hands or servants and as small, free, landholding farmers. It also shows that opportunities were present for the economic betterment of both slaves and free blacks. Such opportunities were very limited and there were no wealthy or influential rural blacks in the county, but their story, as incomplete as it is, gives us a part of our history that has been almost completely missing and is necessary to keep the next generation of Yale students from being surprised by the reality of Northern slavery.

1.

Slavery in Connecticut: The Background

S lavery was never established in Connecticut by law. Instead, it grew informally and was sanctioned by several statutes and court cases over the course of the colony's history, so that by the late eighteenth century it appeared as a fully government-approved institution. In this way the slave population of Connecticut grew from the first Indian slaves of the second quarter of the seventeenth century, acquired as a result of the Pequot war, to a peak population of about 6,500 African slaves by 1774, just before the American Revolution.

From that peak year the African or black slave population quickly declined. In 1790, the first year in which a national census was conducted, Connecticut slaves numbered 2,759 and the free black population stood at 2,801. Approximately half of the state's slaves had been freed. By the 1810 census, the slave population had dropped dramatically to just 310 and by 1820 it stood at only 97. In 1840, eight years before the institution was formally abolished, only 17 slaves were counted in the entire state.

The reason for this steady decline lies in the slave legislation that was passed in Connecticut's General Assembly from the Revolutionary War to the end of the century. During this time the legislative trend was one of abolition. These laws were all passed in an attempt to gradually ease the institution out of existence in such a way that the property rights of owners were not violated and that freed blacks did not become a burden on the town.

It would be pleasant to report that the motives for this abolition sentiment in Connecticut were morally based and that there was a natural abhorrence on the part of the state's citizens to the idea of a man or woman owning another human being. There were some in the state who honestly had moral qualms about the peculiar institution, but the majority of those opposed

to slavery were motivated by more practical concerns. Chief among these was the conviction that slave labor took jobs, especially menial ones, away from the poor. The preface to the 1774 law that banned the importation of any "Indian, Negro, or Mulatto slave" into Connecticut clearly stated its reasons as that "the increase of slaves in this colony is injurious to the poor and inconvenient."

The Legislation of Freedom

Regardless of the motivation, legislative efforts to abolish slavery in Connecticut began in 1784, about ten years after the slave population reached its peak. This legislation provided for the gradual emancipation of slaves by mandating that all Negro or mulatto children born in the state after March 1, 1784, would be free of servitude upon turning twenty-five years old. As those slaves born before 1784 died off and those born after that year turned twenty-five, slavery gradually disappeared. The institution died without denying masters a fair return on their investment and, more important, without suddenly depositing a large number of men, women and children into the state's labor market. In this way competition with the state's poor could be avoided as blacks were absorbed into that market one by one over many years.

Four years after the landmark legislation of 1784, further legislation was passed that tightened the penalties for being involved in the slave trade. A 1774 law had made it illegal to bring any slave into the state "to be deposited or sold." The 1788 law made it illegal to be involved in the slave trade directly or indirectly. In addition it became illegal to transport out of the state any free black or slave entitled to be set free at age twenty-five. In this way, the practice of selling free blacks back into slavery in another state was legislatively opposed, as was the attempt to circumvent the 1784 law by taking blacks who were about to be automatically emancipated to be sold in another state. This law was further strengthened in 1792 when it was made illegal to transport any slave to be sold out of the state.

These laws were laudable but not very effective. Most slave owners felt some sense of responsibility for their slaves and would not have taken them out of the state for sale in any case. But for those who sought to forestall their potential losses, the law does not seem to have been much of a deterrent. In the period from 1790 to 1797, action was brought against fifteen men in the entire state for transportation and sale of slaves contrary to these laws. These cases involved a total of only sixteen blacks (eight Negro boys, four Negro women, four Negro men and two just designated as Negroes).[1]

The circumstances surrounding these cases give some perspective on the problem of illegal slave trading. All of these cases in Fairfield County were brought by only two men. One was Ebenezer Mallery of Newtown, who hauled Hall Bradley of Huntington and Cyrus Hard and James Glover, both of Newtown, into the county court for transporting Negroes across the New York border with the intention of selling them.

The man who brought all of the other cases was Isaac Hillard of Redding. He prosecuted two Redding men, Steven Betts and Hezekiah Sanford; four Newtown men, Philo Booth, David Nichols, Austin Nichols and Austin's brother Richard; and a scattering of men from Danbury, Stamford, Norwalk and Ridgefield. For each of these cases, Hillard and Mallery petitioned the General Assembly to be reimbursed for the expenses incurred bringing the slave traders to trial. They further asked that the reimbursement be made out of the fines that the courts would levy, fines that normally went into the state treasury.

From later evidence gathered by Redding's historian, Charles Burr Todd, Hillard was a professional troublemaker and was not highly thought of anywhere in the western part of the state.[2] He was, in fact, referred to in a contemporary 1804 source as "a wretched vagabond." Granted, these comments were made by his political opposition in the newspaper the *New England Republican* in reaction to Hillard's pamphlet espousing radical Democratic principles in mediocre verse, but his tendency to put himself in the most irritating position possible on any social issue is attested to by these and other sources.[3]

The exact number of slaves sold in violation of the law will never be known, since clandestine activity leaves no records. The fact of such a trade made evident by the tremendous exertions of Hillard and Mallery, and the probability of other undetected cases, indicates that the practice occurred regardless of the deterrent of state law.

While these cases were being played out in the courts, in 1794 impatient abolitionists demanded the immediate freedom of all of the state's slaves. As a result, the lower house of the General Assembly actually passed a bill that made it illegal for any "Negroe, Mulatto, or other person to be held as a slave after April 1, 1795." In addition, the law provided for the education and maintenance of all slaves who were emancipated as a result of this bill. Unfortunately for the abolitionists, the upper house had already passed a milder bill regulating the procedures for emancipating slaves, and the debate to resolve the differences in these bills began too late in the session to be effective. Both bills were tabled until the next session and by then the abolitionist ardor had dimmed. Legislative emancipation would wait until 1848.

There was a further attempt in 1797, however, to speed up the process of emancipating slaves. In that year, the age until a slave could be held in servitude was lowered to twenty-one. This brought the servitude of blacks in line with that of apprentices and indentured whites, who would be free upon attaining their majority. This perception of slavery as similar to, or the same as, indentured servitude was prevalent in the Northeast throughout the late eighteenth and early nineteenth centuries.

The Problem of Poor Free Blacks

Just as there was acceptance of slavery from the earliest days of the Connecticut colony, there was also an ongoing concern with the problems of emancipation. The slave-as-indentured-servant attitude created the presumption that the slave would be free in the near future. The welfare of the freed slave then became an important concern of colonial leaders. Again, this concern was not as much a moral concern for the freed black's welfare as it was a concern for who was to be responsible for the freed black if he became indigent and a ward of the town. Town leaders were also concerned that there were masters who, when faced with the prospect of caring for an aging and ailing slave, would simply emancipate him and leave it to the town to care for him.

As early as 1711, a law was passed that addressed these concerns by laying the responsibility for a freed black who was in want squarely on the shoulders of their former owners. The selectmen, acting on behalf of the town, were to care for all impoverished free blacks with town funds in cases where a former master refused to take responsibility. The selectmen then had the right to bring suit against that master to recoup the losses sustained by the town for the former slave's upkeep. With this legislation, the principle was established that the master's responsibility for his slave extended beyond his period of ownership.

This principle sometimes proved an impediment for later attempts to encourage emancipation. In the early 1790s when emancipating one's slaves became vogue, masters often became reluctant to do so since there was a strong possibility they would eventually be responsible for their former slaves' welfare, especially when old age with its concomitant illnesses set in. This problem was overcome with legislation in 1792, which drew together and codified all previous legislation regarding the procedures of manumission and, in addition, assured the town authorities that the slave was not being dumped on the town's welfare rolls, while also insulating the master from future liability.

By this law, the master must first apply to either two civil authorities or a civil authority and two selectmen to form a committee of emancipation for the prospective free black. The duties of this committee were to first inquire into the slave's health. In addition, the slave must be between the ages of twenty-five and forty-five, thus keeping the master from jettisoning an old slave who had outlived his economic usefulness. The committee was also charged with making sure that the slave wanted to be free. Unlike the abolitionist assumption that all slaves had a passion to be free, the Connecticut law recognized that some slaves did not find servitude an undesirable situation, but instead desired the security that resulted from a master who was responsible for his welfare, especially as he got older. (At least one example of this attitude was found in Newtown and will be treated later.)

After meeting all of the qualifications, the committee issued a certificate that allowed the owner to proceed with the formal emancipation. An emancipation statement was drawn up and recorded in the town's land records. In this way the manumission was treated as any other property transfer; ownership of the slave passed from the master to the slave himself. In the process the master was discharged from "any charge or cost which might be occasioned by maintaining or supporting the slave made free."

As a result, freeing slaves became a formal process that left records. Emancipation documents can be found in most Connecticut towns starting in 1792 and stretching to as late as the second decade of the nineteenth century, when the slaves that were still in servitude were becoming too old to meet the age requirements.

This legislation, as haphazard as it might seem, accomplished the abolition of slavery in the state with a minimum of trauma for the slave owner and the slave himself. By the census of 1830, only twenty-five slaves were counted in the entire state and by the time of the law formally abolishing slavery in Connecticut in 1848, it was estimated that there were only six slaves left, and all of these were over the age of sixty-four. In towns such as Newtown, the slave population disappeared even more quickly than for the state as a whole. By 1820, just four slaves were left in Newtown and the 1830 census lists only free blacks. Redding was free of slaves even earlier. By 1810 there are no slaves listed in the census records.

The abolition of slaves in Connecticut occurred at a time when the slave population of the South was just beginning to rise dramatically. This was the result of the increased demand for cheap cotton, which was made possible by the invention of the cotton gin in New Haven at the end of the eighteenth century and technological developments in the British cotton textile industry. The increasing demand for cotton created a need for field

hands to harvest the cotton crop on the larger plantations, and slave labor filled that need.

When Southern slavery is considered in detail against that of the North, a number of other contrasts emerge. Slavery not only developed differently in the North than in the South, but the very nature of slavery was different here than in the South, where it became an important part of that region's economy. These contrasts will become apparent as rural slavery in Fairfield County is examined a little more closely.

2.

The Slaves of Newtown

*I*t is not known when the first slaves were brought into central Fairfield County, but according to the "account of the number of inhabitants" made by the colony in 1756, there were twenty-three blacks living in Newtown by that year.[4] These blacks were presumably all slaves, as the movement for emancipation had not yet begun. A second "account of the number of inhabitants" was made in 1774 and by then the number was fifty-nine, with no indication of any free blacks. The black population seems to have reached its peak by the time of the first national census of 1790, from which there was a slow steady decline until the end of the first quarter of the nineteenth century.

A partial profile of this slave population can be developed from the early national census data focusing just on Newtown. In the 1790 census, there are 71 slaves listed for that town. This amounted to 2.5 percent of the town's population of 2,774. (There was also one free black family consisting of 6 people and headed by a man named Cato.) These slaves were spread among forty-six families, so only 10.3 percent of Newtown's families were slave owners. (These figures are roughly the same for Newtown's neighboring towns.)

With seventy-one slaves in 1790 among forty-six slaveholding families, the number of slaves held by any given family was very low. In fact, of all of these families, thirty-three, or 72 percent, owned only a single slave; nine families owned two slaves each; and only five families owned more than two. Nathaniel Briscoe was the largest slaveholder with nine, but most of these were members of the same family. This is an obvious contrast with the situation in the South, where plantation owners might own as many as fifty to five hundred slaves each.

Since the Southern plantations were large-scale farm operations with a high demand for field labor, their slaves were predominantly utilized as field hands. In the North, however, rocky, thin soils and hilly terrain made large-

scale farming very difficult. The small New England farms that resulted from these conditions did not need very much in the way of labor beyond the family itself. One or two extra hands might be needed in the busy planting and harvesting seasons, but there was little use for gangs of field hands. As a result, Northern slaveholders owned few slaves, as is reflected in the statistics of the 1790 census.

There is an interesting exception to this generalization of small farms and few slaves, however. In the middle decades of the eighteenth century, several farmers tried to develop plantation-scale farms in Narragansett, Rhode Island. This is an area nineteen by fourteen miles that is located in the southwestern area of the state, adjoining Narragansett Bay.[5] Archaeologists Jerry Sawyer, Warren Perry and Janet Woodruff, working out of Central Connecticut State University, have also found and excavated a plantation-like farm in the town of Salem, Connecticut, that was obviously set up on the Narragansett plantation model.[6] The discovery of these large-scale farms has invited the comparison with the Southern plantation system and the claim that Northern slavery is, after all, not that different from the South.

Looking carefully at the documentation for these Northern plantations, however, it is immediately apparent that they were not set up to raise a single cash crop like their Southern counterparts. Instead, they produced a variety of goods such as cereals, dairy products and livestock for export to the Caribbean Islands. In addition they were much smaller, containing only one to two thousand acres, as opposed to the vast sprawling Southern plantations. The most distinctive difference, however, was the number of slaves, which averaged only ten to twenty, as opposed to the large work gangs of slaves that could be found in the South. Over all, the Narragansett plantations were not really comparable to the South. They were also confined to a small area in southwest Rhode Island and southeastern Connecticut where they lasted only for a couple of decades and then failed, proving their lack of viability. The usual pattern of slavery for New England in general and Connecticut specifically was one of small farms and few slaves.

Slaves as Servants

The low number of slaves per household meant that the relationship that existed between the slave and his owner in the North was different from his Southern counterpart. Whereas the Southern slave was only one of many and was managed by overseers who were often other, higher status slaves, the Northern slave was an individual who dealt directly with his master. He

was seen as a family servant or as a hired hand rather than as part of an amorphous labor gang.

The almost paternal nature of the relationship between slave and master in Connecticut has been commented on by a number of modern sources, but even sources contemporary with the period of slaveholding tend to confirm this relationship. The well-known Madame Knight, who kept a journal of her journey across the state of Connecticut in 1704, recorded her criticism of the people of New Haven for being too familiar with their "servants." By her criticism of being "too familiar," she confirms the closeness that she witnessed. In addition, her use of the word "servant" for slave reflects the mindset of New Englanders, and her usage was not unique. In almost half of the documents relating to Newtown slaves, they are referred to as Negro servants. Clearly the relationship of slave to owner was a lot closer in the mind of the Northern master than in that of the Southerner.

The close relationship that often developed between slave and owner in the North can also be seen in the will of the Newtown widow Mary Booth. Drawn up in 1811, thirteen years before her death, it provided for

> *the emancipation of my slave and servant black woman named Sue, from the time of my death and I do devise and give to her, the sd Sue, one cow and two sheep. Also the use and improvement of the lean-to part of my dwelling house during her natural life, with furniture necessary to uphold life and if the provisions should prove inadequate to her support, my will is that she be maintained by the children of my son, Smith Booth, and the children of my son Reuben Booth in proportion to what they will respectively receive by virtue of this my will.*

Unfortunately, Sue was an old servant and she died three years before Mary Booth, never having known freedom. Her freedom, however, may not have been of importance to her. In the census of 1800, Mary Booth was listed as having three slaves, one of whom must have been Sue. By the 1820 census, Mary was one of only four slaveholders in Newtown. Sue was her only remaining slave. In the meantime, she had emancipated her two other slaves. One of them, Prince Booth, was formally emancipated on December 12, 1803. Why was Sue not also liberated? Two answers are probable here. First, she was too old (over forty-five) to be emancipated under the 1792 emancipation procedures, and second, she did not want to be free with all of the responsibilities for her own welfare that the condition of freedom carried. Both of these answers are probably correct. Sue was not only too old to be legally emancipated, but she was also too old to successfully establish herself in an independent household.

Another part of the reason why Sue may have decided to remain in bondage was the relationship that existed between herself and Mary Booth. The provisions of Mary's will clearly set out the circumstances under which Sue was to be taken care of for the rest of her life. This appears to be more than simply meeting the legal requirements to provide for indigent slaves, since Mary stipulated that she was to have her choice of furniture "necessary to uphold life." In addition, Sue was to be given the use and improvement of the lean-to part of the dwelling house. In the saltbox houses of the time, this would have been the part of the house under the long slanting rear roof, where servants and older children usually slept. Again, Sue was being treated more as a trusted family servant than the typical slave.

That slaves in rural Fairfield County functioned more as servants than laborers is borne out by the occupations of the slave owners. Many were not simply farmers who needed an extra hand in the field, but were some of the town's most prominent men, who made their living other than by farming, and thus had no need for a laborer. Chief among these was William Edmond, who was a lawyer, served in both state and national political offices and can be considered one of Newtown's most prominent citizens. His slave girl, Jenny, was born on May 11, 1787, and she was duly registered with the town clerk since, under the three-year-old law providing for the gradual emancipation of slaves, she was entitled to be free when she turned twenty-five in 1811. Jenny was not his only slave, however. Since she was born into his household, her mother must have been a slave as well. Unfortunately, as is so often the case, her mother's name has not survived, nor has the identity of her father, who may or may not have been a slave. Regardless, Jenny and her mother worked and also lived as servants in the Edmond household. In the attic of the Edmond house, which still sits on Main Street just north of the library, there is a walled off area that is quite probably where Jenny and her mother lived, reminiscent of the servants' quarters of the post-slavery era.

Even ministers, who were among the highest-status individuals in the community, were slave owners. Reverend David Judson, who served Newtown's Congregational church between 1746 and 1776, had at least five slaves. His probate inventory, dated March 4, 1777, lists all of his considerable worldly goods, including "a Negro man and Woman; A Negro girl Temp; ditto Silvia; a Negro Boy." These may have constituted a single slave family but, regrettably, three of the names are not given, and there is no record of what happened to them upon the distribution of Reverend Judson's estate.

Jehu Clark, another minister of the Congregational church who served from 1799 to 1816, was also a slave owner. In the Trumbull land records

dated September 9, 1801, is a bill of sale that conveys a "Negro girl by the name of Rose, the daughter of Philip and Mary Glover so-called…to be of service of J. Clark until she shall be of full age of twenty five." Rose had been born on January 12, 1791, so she was born under the gradual emancipation provisions of the 1784 law, as was Edmond's Jenny. Since Rose was only ten years old at the time of her sale to Clark, she was obviously separated from her parents, who presumably continued to live with Sally Sherwood, Rose's former owner.

This is one of only two cases discovered so far in the local records in which a child was sold away from her parents. The second one was discovered very recently and is a unique bill of sale for a slave. In 1813, Abel Bennett, who lived near the shores of the Housatonic River, sold a girl named Genny to his neighbor Philo Curtis, who lived about a mile to the west on Riverside Road near the end of the road that bears his name today. At the time, Genny was only three years old and she was sold for twenty-five cents. This is the youngest and cheapest slave sale yet encountered and it strongly suggests a token sale. The mother of Genny was given as Sucky, who had to have been a slave of Abel Bennett. It is quite probable that Sucky was either dead or otherwise incapable of taking care of her daughter and the Curtis family was willing to do so. The token twenty-five cents would have ensured that after raising her, she would not be reclaimed by Bennett just as she became economically useful.

We do not know what ultimately happened to Genny. According to the bill of sale, she was due to be freed on April 22, 1831, when she turned twenty-one, but no emancipation papers were ever filed. There is a baptismal record for her in the Trinity Episcopal Church records, indicating that Curtis was looking out for her spiritual well-being. Although this is a case where the child was sold out of the family, it is clearly extraordinary and was done for the child's welfare, but it also testifies to the paternal nature of many slave-master relationships.

The practice of separating a child from his or her parent, which nineteenth-century abolitionists loved to hold up as a powerfully emotional reason for doing away with slavery, was not as common as it was once thought to be, even in the South. The extensive research done by Robert Fogelman and Stanley Engerman in the mid-1970s, which resulted in the book *Time on the Cross*, has documented the practice of separating families, but the authors found that owners did it reluctantly, since it affected slave productivity.[7] In the North, the practice appears to have been not just infrequent but truly rare.

Very few bills of sale for slaves have survived, so the origins and cost of most slaves is unknown. When Caleb Baldwin of Newtown registered the

children of his slave, Phillis, he listed both her and her firstborn child as being born in Stratford. This is the only town of origin for a slave that has been found except for Trumbull, the town where Reverend Clark's Rose was born. Many, if not most, of the slaves who have been traced from the 1790 census were undoubtedly born in the town in which they were enumerated. The origins of their parents or grandparents, however, are unknown.

There are tantalizing hints that some of the slaves from this area came north from Stratford. Many of the proprietors and first settlers of Newtown came from Stratford and for several generations many of them, such as Caleb Baldwin, maintained close contact with the coastal members of their family. Stratford was a thriving seaport during the eighteenth century, specializing in trade with the Caribbean Islands. The island trade with New England has long been known as part of the "triangle trade," one leg of which transported slaves from Africa to the islands. Slaves not sold in the islands were often carried to New England and sold in Providence or Newport. Although Rhode Island was a known supplier for many New England slaves, it is suspected—although not documented—that slaves were smuggled into Connecticut's seaport towns, especially after the importation of slaves was made illegal. Unfortunately, since this was clandestine activity there are no records concerning it and the only indication that it ever occurred is rumor and local folklore, which is always a dangerous and uncertain source of historical information. However, recent research that is ongoing among Stratford shipping records is beginning to establish a correlation between captains of island trading vessels and slave ownership, which in the future may help to clear up some of the mystery of slave origins.[8]

The Value of a Slave

The average value of a slave is just hinted at in four surviving bills of sale. Jehu Clark's slave, Rose, cost forty-three dollars in the bill of sale quoted above. In another that was located in the collections of the Cyrenius H. Booth Library, a Negro boy named Ned was sold to Lemuel and Mary Sherman on March 25, 1787, for ten pounds.

A truly remarkable bill of sale was for a Negro girl named Time, dated March 1, 1804. This sale was one of the few recorded in the Newtown land records and it established that Sarah Nichols sold Time to Titus, "a free Negro of the town of Fairfield," for the amount of fifty dollars. The amount of the sale compares with the other two sales, indicating that the sum of fifty dollars was probably the going price for a Northern slave in his

prime during the last decades of the eighteenth and early decades of the nineteenth century.

The remarkable part of this sale stems from the provision that Time was sold "for and during the natural life of the said Negro girl." Since she was thirty-one years old when she was sold, she was born in 1773, predating the emancipation law of 1784. She was, therefore, to serve her black master potentially for the rest of her life. From the land records of Fairfield we know that her new master, Titus, was a slave of Hezekiah Bradley until August 25, 1802, when he was emancipated. A little less than two years later he bought Time. Further search of Fairfield's records turned up nothing on either Time or her master until December 1, 1815, when the records of the First Congregational Church give her death notice. In that entry she is listed as the wife of Titus. Interestingly, there is no emancipation record for Time in the land records, indicating that she was never formally freed by her husband. She may have been the only wife in the county who was actually owned by her husband!

Although this case of a free black buying a black slave appears to be strange, it is not at all rare. In a recent article in *American Heritage*, Philip Burnham claims to have found records in the 1830 census of 3,775 free blacks who owned a total of 12,760 African slaves.[9] Although the majority of these black slave owners owned only a few slaves each, some of those in Louisiana and South Carolina owned as many as seventy or eighty. Most of these black masters were in the South, but Burnham mentions that blacks owning blacks were recorded in Connecticut by 1783 and that some blacks still owned slaves in the Northeast as late as 1830. Since Connecticut recorded only 25 slaves in that census, Burnham's comment probably applies more to other states in the region, but in the first federal census of 1790, there are six free black families in Connecticut who owned slaves. There have been no other cases of this type discovered so far in Fairfield County.

A better idea of the value of local slaves can be derived from probate inventories. These inventories were compiled for everyone who died and had real estate or personal possessions. In them all of the worldly goods of the deceased were listed with their values, down to the last bottle and scrap of linen. Since slaves were personal property in the same way as cattle, they too were listed and values for them were given. Probate inventories for a number of Newtown estates containing slaves have been located in the Danbury Probate Office for the period from 1760 to 1800, which spans the peak and much of the decline of Northern slavery. In these inventories, twenty-two slaves with their values were listed. For "Negro men," these values ranged from five pounds to a high of sixty pounds, but they clustered

around thirty-five pounds, which is the calculated average. The low value of five pounds was for Abial Botsford's slave, Samson, who was probably an old man and whose earning power was correspondingly low. A similar low value of nine pounds was given for Sue, the slave of Mary Booth mentioned above. It is known that she was in her sixties and thus at the end of her productive years. The worth of the other six "Negro women" ranged from twenty-eight to fifty pounds, with a calculated average of thirty-five pounds/ six shillings, virtually the same as for men.[10]

Two other categories of slaves were also given, "Negro boy" and "Negro girl." Unfortunately, there were too few of them to give a reliable average. For the category Negro boy, only one value could be found, for fifteen pounds. For Negro girls, four values were located ranging from eight to twenty-eight pounds. As few as these are, it is obvious that Negro children were considered to be worth less than adults since children were less productive.

One other category that appeared on two occasions was "Negro wench." In the eighteenth century this term did not have the lascivious connotation that it has today. Then it meant a young girl or, more frequently, a young female servant. For the purposes of this study these were averaged in with the category of Negro women. One entry that remains strange, however, was that in the inventory for Donald Grant, compiled in 1763, which read, "a Negro wench and bed…£36."

These values compare favorably with those of another larger study of slave values that was done by Dr. Vincent J. Rosivach of Fairfield University and delivered in a lecture to the Fairfield Historical Society in October of 1992.[11] In his study, Dr. Rosivach searched the probate records of Fairfield and located 111 slaves for whom values were given. His study found that the median value of a man was thirty-eight pounds and that for women was only fifteen pounds. The median value for a wench, of which he found nine records, was thirty pounds, and for children, boys were valued at thirty pounds and girls at twenty-five pounds. The substantially lower value for women may be a result of the way in which the categories for females were divided. The category "wench" would have been for productive servants who were accordingly more valuable. The category of "woman" would have included many older, less productive females and thus skewed the average for woman downward.

Dr. Rosivach's study had a much larger statistical base and probably reflects more accurately the value of slaves in Connecticut in the later half of the eighteenth century. It is encouraging, however, that with the exception of his median value for women, the other values found for Newtown slaves were not very different from the Fairfield data. It is possible

that the differences that do exist in slave value may be a result of location. In the coastal areas the demand for slaves may have been different than interior areas that were more agriculturally oriented. This difference in demand would be reflected in slightly different prices in each area, but this is a subject that needs more study.

The raw pound values for slaves do not mean much to those who live in a dollar economy over two hundred years removed from the height of slavery. A few values for other personal goods, however, help to make the value of slaves more meaningful. In the same probate inventories containing slave values, one of the most frequent items of personal property was a pair or yoke of oxen. Of twenty-two listings, there was a tight cluster of values around the calculated average of thirteen pounds/ fifteen shillings. Therefore an adult male slave was worth two and a half ox teams. In terms of cows, which were valued at an average of four pounds, an adult male slave was worth 8.75 cows. He was also worth about four times the value of a horse, which had an average valuation of eight and a half pounds.

The standard of living and general living conditions of slaves are extremely difficult to determine. There are virtually no records for slaves that list personal possessions like the probate inventories compiled for most free whites. Likewise, no one ever thought to record the living conditions of slaves any more than they would have recorded the living conditions of their cattle or even other poor colonial residents.

Housing for Slaves

Information on slave housing is as scarce as is knowledge on other areas of slave life, but occasionally scraps can be found in probate documents. From Mary Booth's will, for example, we know that her slave, Sue, was apparently living in the lean-to or garret of Booth's saltbox house. Since Sue appears to have been a personal or domestic slave, it is probable that such slaves usually occupied some out-of-the way part of the house such as the lean-to would have been.

One probate document, the inventory for Jonathan Booth's estate, lists a "slave house" among the estate's outbuildings, indicating that for some slaves separate quarters were maintained. It was first thought that detached quarters might have been used only to house male field hands, leaving female domestic slaves to live in the owner's house in order to be closer to their area of service. Since the only two slaves that have been discovered for Booth were Dorcas and Lydia, both women, that assumption is apparently wrong and detached quarters may have been used to house both males and females.

The quality of Booth's slave house can be guessed at from its valuation at fifty shillings, or two and a half pounds. This may be compared to the Booth homestead that was valued at eighty pounds, which was above average for a Newtown residence of this period. Booth's barn was also valued at fifty shillings, from which we may infer that the slave quarters were probably a barn-like shack. Where the barn had size, which contributed to its value, the slave shack would have had a fireplace that would have raised its value to that of the larger barn. Detached quarters for slaves when they were built, then, were probably simple, rude structures.

Slave Social Life

A great deal of the social life of the Fairfield County rural slave will remain closed to us for lack of documentation. On some matters, such as slave marriages, however, there are occasional tantalizing pieces of information that allow us to draw some tentative conclusions concerning the basics of slave social life. For example, since there were few slaves in the average slave-owning households, marriage must have often occurred between different slave-owning families.

One documented case of such marriage is that of Phillis, the "servant of Caleb Baldwin." When Phillis's son, Joseph Freedom, was born just after 1784, Baldwin—the town clerk—carefully added Joseph's name and birth date to the town's vital records with all of the other "children of Tobe Curtis by his wife Phillis." Tobe (Tobias) Curtis was a slave of Nehemiah Curtis who was born in 1760 and emancipated in 1791, seven years after the birth of his son. (Tobe's emancipation is the first one recorded in Newtown's land records.) The fact that Baldwin refers to Phillis as Tobe's wife indicates that the marriage occurred between slaves in the Curtis and Baldwin households.

Many questions are unfortunately left unanswered by this record, especially in which household Phillis and Tobe lived, or if they lived together at all. One clue indicating possible living arrangements, however, comes from the brief biography of Nero Hawley, which was written by E. Merrill Beach in 1975. Hawley was a slave, Revolutionary War veteran and finally a free black in Trumbull. In 1761, while he was a slave of Daniel Hawley, he married Peg, the slave of Reverend James Beebee. Beach has established that after the marriage, Nero moved into the Beebee household with his wife. At this time it is certain that Nero still belonged to Daniel Hawley because in 1782 Daniel Hawley emancipated him, an act that could only be performed by his owner. Since Nero worked for Beebee

at his gristmill while living in his household, there must have been some sort of business arrangement between the two masters. Unfortunately, arrangements regarding revenue earned by Nero during the remaining years of his bondage have not survived.

The children who were born to Nero and Peg appear to have been the property of Reverend Beebee, as two of them are listed in Beebee's estate inventory after the reverend's death in 1785. This is consistent with the principle that the status of slave is determined by the status of the mother, and children become the property of the mother's master. The other two children, however, must have been given to Nero before Beebee's death and the two who were listed in the inventory were apparently inherited by Nero, who was by then a free black. Nero formally emancipated all four of his children in 1801 when they were between twenty-six and thirty-four years of age.

It is possible that similar arrangements may have applied to the family of Tobe and Phillis Curtis. Unfortunately, no emancipation records have survived for Phillis or her two children, so it is impossible to determine whether their case proceeded along the same lines as that of Nero and Peg. The Hawley scenario is at least a well-documented case of how the same problem was dealt with in one central Fairfield County town.

Slave Social Structure

Beyond their families, there is virtually no other data on slave social structure and, in fact, there may have been no such social structure at all. Because of the small number of slaves and the scattered nature of their distribution across the county, social structure beyond that of a nuclear family could not exist. There could be no slave society as might be found on the Southern plantations, where the number of slaves on an estate could number one hundred or more. Under the Southern circumstances status and rank developed within the slave population and individuals rose above their fellow slaves as some of the more capable of them became overseers and supervisors. A crude class structure also developed as the household and serving slaves differentiated themselves from the field hands. None of this could happen on a farm where there were at most five slaves and they constituted a single family.

Likewise, with the scattered nature of the slave population there were limited opportunities for social interaction between slaves. In a series of articles for *The Connecticut Magazine* published in the early years of this century when first- and secondhand memories of Connecticut slavery

still existed, Judge Martin Smith from Suffield wrote a memoir entitled "Reminiscences of Old Negro Slavery Days in Connecticut."[12] The series is remarkable for preserving a good deal of information on the social life of rural blacks in the early years of the nineteenth century. The author relied on oral tradition that was obtained from his father as well as the memories of his youth, and most of it appears to be reasonably accurate and genuine. According to Smith, much of the social interaction between blacks in the later days of Connecticut slavery took place when the master visited neighbors and took his "Negro" along as a servant, or during occasions—such as a husking bee or other such social gathering—when the neighboring blacks gathered in a parallel social gala with their masters' families. In all cases it seems that black social interaction took place as an adjunct of white social interactions.

Socializing was also heavily limited by state legislation that severely restricted the movement of all blacks. By law, no black could travel beyond the boundaries of the town in which he lived without a pass or other written authorization from a justice of the peace or his master. Any black apprehended without such a pass was presumed to be a runaway and was treated accordingly. Any ferry man or, in fact, anyone who transported a black without a pass was subject to arrest and a fine of up to twenty shillings. Even within the town, no black was "to be abroad in the Night-Season, after nine of the clock," without written permission from his owner. All of this made running away more difficult for slaves but it affected free blacks as well, since it was applied indiscriminately. It was impossible to tell whether a black was slave or free, and therefore the regulations applied to all blacks regardless of their status.

Slaves undoubtedly fled from owners in central Fairfield County, but this does not appear to have occurred often. Only one case of a runaway in this area has been found. On November 3, 1798, a twenty-year-old woman named Candace fled from her master, Philo Norton. She was described as "slim built, yellowish complexion, middle size, slim face, carried with her a light chintz gown, brown flannel short gown, black shirt and had on when she went away a beaver hat and light chintz shawl. It is supposed she is under the convey of some Negro man…$5.00 reward and charges paid."[13] This appears to be a case of a slave running off so that she could be with her lover, rather than that of someone who was fleeing bondage out of frustration or discontent with the institution. Its singular nature suggests that this area was not plagued with discontented slaves threatening at any moment to take flight.

There was an inherent distrust of slaves on the state level, however, which is reflected in the laws restricting the movement of blacks, cited above, and in

the laws that prohibited trade with servants. Specifically, no one was allowed to receive money, goods or merchandise from a "Negro" servant unless that servant had a written order from his master. In other words, a slave could neither buy nor sell goods without his owner's express permission. This law was passed to deter the trading of goods stolen from the owner. Again, there are no recorded instances in this area of a white having been prosecuted for unlawful trading with a slave.

These laws that appeared prominently in the late eighteenth-century law had disappeared by the beginning of the next century. There was, undoubtedly, resentment of these laws on the part of free blacks who fell under their provisions even though they were free, but since free blacks had no political power, the demise of these restrictions was more the result of the decline of slavery itself. With the provisions of the gradual emancipation law coming into effect by the early years of the nineteenth century and the movement to emancipate slaves dominating the decades of the 1790s and 1800s, there were too few slaves to worry about. Restrictive legislation was simply not needed as the population of free blacks grew toward 100 percent.

From the census data for the entire state, the success of the gradual emancipation efforts of the state legislature has been readily documented, and the process was substantially completed before the abolition act of 1848. The process was completed even earlier in central Fairfield County. In Newtown there were seventy-one slaves in the 1790 census, but by 1800, the number had dropped to only eighteen and the number of free black families had risen from one to four. At least twelve slaves had been formally emancipated in the 1790s, and another nine were emancipated over the next fifteen years. The fate of the remaining thirty-two is unknown. It is probable that many of these fell under the gradual emancipation provisions of the 1784 and 1797 laws, and were freed without any formal procedure or documentation. It is also possible that many of these remaining thirty-two were given their freedom but the act was never recorded. This is in line with the fabled Yankee streak of independence, which led to the stubborn refusal to register anything, including land sales, since the sale was no one's business but the seller and buyer.

By 1820, there were four slaveholders with one slave each, and these were probably elderly and not eligible for emancipation, like Mary Booth's slave, Sue. Meanwhile the total free black population had risen to 110. Slavery had ceased in Newtown by 1830, and in Redding two decades earlier. By these years the free black population had risen slightly to about 3.75 percent of the total population of both towns, a percentage that remained fairly constant until the Civil War.

From Slave to Freeman

The Problem of Surnames

The greatest difficulty in trying to trace what happened to slaves after they were emancipated lies with their names. Most slaves were known only by a single name. Some of these were taken from classical literature and are therefore distinctive. Names such as Cato, Cesar (Caesar), Agrippa and Primus are fairly easy to link to African Americans, since they were generally not given to whites. Many blacks, however, were given more common Christian names, and these are easily confused with one another. In Newtown, for example, there were four Neds, five Jennys and five Roses. Each of these had different owners, so while they were still slaves, it is relatively easy to keep track of them because they were usually referred to with respect to their owner. Once freed, however, they became extremely difficult to separate and identify.

Once they became free blacks, most former slaves took surnames and it was a common practice to assume the surname of one's former owner. Tobias, the slave of Nehemiah Curtis, therefore becomes Tobias or Tobe Curtis and Zephaniah, the slave of Daniel Booth, becomes Zephaniah Booth. When it was one of the common Central Fairfield County family names, the surname is often a clue to who their former owners may have been. Unfortunately, this works for less than one-third of the free blacks for whom we have data.

Another common practice was to adopt the surname Freeman or Freedom, in celebration of their new status. These surnames, however, were also bestowed by the U.S. Census. Up until 1810, census takers seemed content to record free blacks under their single name with the designation "Negro" after it. Therefore, there are black families listed under the head of the household as "Cato a Negro," "Lemuel a Negro" and "Tobias a Negro." In 1820, however, we find these changed to Cato Freeman, Lemuel

Freeman and Tobias Freeman. Apparently the census taker was reluctant to record a name unless it had a proper surname, and so Freeman appears to have been added for the sake of record completeness. Ten years later, the census taker was less punctilious and the surnames were dropped in favor of the small notation "Negro." By 1840, the surname fanatic had returned and we again find Freemans. To complicate matters, however, some of the surnames changed. Ozias, who had been Ozias Freeman in 1820 and Ozias Negro in 1830, had become Ozias Platt by 1840. If his first name had not been so distinctive, there would have been no way to know that this was the same man. (His identity is also confirmed by other records.)

In many cases these changes are just confusing and occasionally annoying. In the case of Tobias, however, name changing may have had legal implications. Tobias was a slave of Nehemiah Curtis and so was known as Tobias Curtis, which identified him as belonging to the Curtis household. In his emancipation document he is simply referred to as Tobias, but two years later, when he bought a house as a freeman, his name on the deed is given as Tobias Curtis. In 1805, when this property was taken to satisfy a debt, he is addressed in the court order as Tobias Freedom. The only way that we know Freedom and Curtis are one and the same is that the property descriptions for both the purchased property and the attachment of the house are the same. A good lawyer today, however, could easily make the claim that the property was taken improperly and that it still belonged to the estate of Tobias Curtis. To further complicate matters, when Tobias's estate was probated after his death in 1825, he was called Tobias Freeman.

Freed Blacks as Laborers

Above all else, the first problem facing freed blacks was that of making a living. It comes as no surprise that most former slaves continued to do what they had done before emancipation: work as laborers on local farms. Of the twenty-three former slaves for whom we have been able to find some notation of occupation, ten were so listed. Another five were listed as farmers, which meant that they had purchased a small plot of land on which they were eking out a meager subsistence.

Another unskilled occupation related to farm laborer was that of a shepherd. At least two former slaves in Newtown served as town shepherd. Bristol Cesar served in that position in 1824. Cesar is also notable because he was one of several blacks from Newtown who served in the Revolution. The second black shepherd was Ned Booth, who served in that position in 1825 and then again in several subsequent years. Ned was an affluent man

for his class. He was freed in 1794 and three years later he had saved $165, with which he purchased a house and property on Slut's Hill (now Mount Pleasant) just north of the village.

Three occupations that required some skill were given for blacks. These skills must have been acquired over a period of time while they were slaves or shortly afterward. Reuben Cam worked as a basket maker and Ozias Platt, who was actually the son of a slave but not a slave himself, was a skilled cooper. William Peck worked as a butcher. This was given as his occupation at the time of his death, but an account of his skills as a butcher comes from another unexpected source: the account book of Josiah Glover.

Glover kept a personal account book, as did almost every literate citizen of Newtown in the early nineteenth century. Since New England towns during this period had primarily a barter economy, with very little money actually changing hands, a personal account book was necessary to keep track of the transactions in labor and goods that were made over the course of the year. Most of these account books listed debts that were owed to the account keeper on one page of a long, thin (six by fifteen inches) book. On the facing page were listed the goods or services that were rendered to pay off the debt. Occasional large ink Xs or slash marks indicate that a specific set of debts had been balanced with goods or services of equal value.

In the dead of each winter from 1836 until 1841, when William Peck died, Josiah Glover gave him a load or two of wood. It almost appears as if Peck could not properly plan his wood supply for the winter or maybe the winters were continuously colder than he expected. Regardless, every summer between May and August, Peck worked a half or full day for forty-two or eighty-four cents, respectively, until the wood was paid off. Sometimes he mowed the hay on one of Glover's fields that were scattered all over the northern half of town. At other times he made stone fences at undisclosed locations. Most frequently he helped Glover by employing his skills as a butcher on his benefactor's hogs.

Freed Blacks as Owners of Real Estate

Although it was primarily a barter economy, some money did change hands and was saved. At least seven former slaves have been found who were able to purchase a small parcel of land—usually including a house—with money that they had saved or with a mortgage that was paid back over the succeeding decade or two. These purchases ranged from two acres with a house in the Zoar District, which were purchased by Cezar Freeman for $180 just a year after his emancipation, to a half-acre plot without a house,

also in the Zoar District, purchased by Cato Freedom for a little over $5 in 1784, not long after his emancipation. (By 1799 Cato had built a house on his small plot and purchased another acre of land for $15.)

The ability of a former slave such as Cezar Freeman to purchase land and a house for $180 just one year after he was freed illuminates another interesting aspect of Northern slavery: slaves were allowed to earn money and keep savings. Since there is no record of Cezar obtaining a mortgage for this land, it appears that he must have paid for it with cash savings and since he had this sum of money just a year after winning his freedom, he must have had a considerable amount of that money put aside before he was freed.

On Southern plantations, Fogel and Engerman discovered that monetary rewards were often given to profitable slaves.[14] They even discovered instances of primitive profit sharing.[15] In addition, they found that a slave was frequently allowed to keep some of the money that he made as a result of being rented out to other plantation owners. Although it may not have amounted to a great wealth, slaves earned money. It is not surprising, then, to find that Northern slaves were also allowed to amass savings.

Although they had savings, there is no reported instance of blacks owning property while still enslaved in Newtown. A deed for the neighboring town of Easton (then Weston), however, demonstrates that a slave could own land. In June of 1798, Nathan Beach of Trumbull and Daniel Hall of Easton sold to Quomano (Quam) Smith, servant to Seth Smith, a sixteen-rod parcel of land with its dwelling house, which was situated on the old boundary between Stratford and Fairfield. (Today this is North Park Avenue in Easton.) This deed is dated nine years before Seth Smith emancipated Quam in 1807, clearly indicating that slaves could and occasionally did own land. This is, however, the only such case of slave land ownership found so far in the central part of the county.

Another land purchase made by a former slave in Newtown has unexpectedly revealed an unusual facet of white-black relations in the early nineteenth century. Zephaniah Booth was emancipated by Daniel Booth in May of 1796. Almost two years later, for twenty-seven pounds, he purchased two parcels of land on what is now Mount Pleasant Road, just northwest of the head of Main Street. The first consisted of a little over one acre of land located on the south side of the road, and the second was a half-interest in a tenement house located on the north side of the highway across from his first parcel. Surprisingly, his tenement's co-owner was white. In a subsequent deed, her name is given as Glorianna Glover and she was the daughter of Benjamin and Mary Glover, a proprietary family that went back to the very founding of Newtown. What is not known is whether she was a resident in

the house at the time that the half-interest was purchased. She was born in 1734, making her sixty-two years old at the time (she apparently never married), so it is possible that he lived in the house and helped take care of her, a job that David Oakely, the man who sold Zephaniah his half-interest, may have done previously. Regardless of the living arrangements, it is of interest that either there was no prejudice on the part of a white woman against being involved as a business partner with a black man, or she was one of the most ardent social liberals of her period.

As with several other former slaves, Zephaniah borrowed money on his land holdings in the form of a mortgage. These mortgage loans were not made by a bank, as they are today, but rather by wealthy town residents. They also were not paid off using a monthly payment book, but were due and payable with interest at the maturity date of the loan. Obtaining these loans, which were secured by land, does not seem to have been difficult for free blacks during the early nineteenth century, as long as there was a clear title to the land securing the loan.

Fifteen years after his original purchase, Zephaniah arranged to buy from Glorianna Glover the northern half of the land upon which the tenement house was situated. The deed was signed in 1807 and two years later he took out a mortgage from Samuel Beers for $50. This amount was paid back just a year later and the mortgage was released. Unfortunately, other former slaves were not as adept at managing credit as was Zephaniah. Several estates of free blacks were declared insolvent at the time of their death and at least one, Tobias Curtis, had his land attached and taken from him by the county sheriff in partial payment of a debt that he owed to Caleb Baldwin. He owed Baldwin $105.59. His house and lot on Chestnut Hill in the Zoar District was valued at $19.

The Socioeconomic Status of Freed Blacks

The general socioeconomic position of Newtown's black population in the first half of the nineteenth century was low. All were poor and none owned much land. In the 1850 census, of the thirty-seven black families that were listed, twenty-one—about 57 percent—were listed as living on the estate of a white family. The occupations of six of those white families were given as farmers, and the black family, or at least the head of the black household, was apparently working as a farm laborer. Two blacks were listed as paupers and were living with a white family who was receiving some assistance from the town for their support. Four blacks were living in the poorhouse.

The census of 1860 gives the added data of estate size estimates, thus yielding a more accurate picture of the economic condition of free black families. In two columns of the census summary books, the dollar value of the family's real estate holdings and the value of all personal property are recorded. Knowing the reticent nature of most New England Yankees, these estimates were probably conservative and understated, but they at least give an idea of the approximate economic status of the family.

Among thirty-five black families listed under Newtown, seventeen (49 percent) were given estate estimates. The average size of the real estate holdings for black families in these estimates was $366.70. The average personal estate, the value of all possessions except land and buildings, was $156. The average value for their entire estate, then, was only $431.25. These total estate values ran from a low of $50 to a high of $900, with the majority of them falling in the $600 range.

These averages are obviously low, but to give an idea of how they compared to the estates of whites, an analysis was done of all white families listed in the 1860 census who gave their occupation as "farmer." Of the total of 818 families listed for Newtown, 315—or 38.5 percent—claimed to be farmers. The average value of their real estate was $2,567, 7 times greater than for their black counterparts. Their average personal estate was $1,330, 8.5 times greater than that for blacks. When the total estates were considered, the average of white families came to $3,745, or 8.7 times greater. From an economic standpoint, black families ranked among the lowest 5 percent of Newtown's pre–Civil War population.

The size of black estates gives us an index of relative wealth, but it does little to show how free black families actually lived. Once again probate inventories have been helpful in giving an indication of what the black lifestyle was in Newtown. Unfortunately, probate inventories for free blacks during the first half of the nineteenth century are not common. Most free blacks died without enough estate to inventory or probate, and many of those that were large enough to become the concern of the court were ridiculously low and often insolvent because of the deceased's debts.

Ned Booth's estate is a good example of the typical free black estate. He died in September of 1825 and left an estate that totals $255, including two acres of real estate, one of which was an orchard lot valued at $50; a house that was valued at $25; and a barn valued at $7. Booth's debts, however, were in excess of $255 and his estate was declared insolvent.

From a later period, Ozias Platt, who died in 1864, left an estate of $233. This included a house, barn, outbuildings and about one acre of land, valued at $150 altogether. The remainder of his estate consisted of seven sheep, ten hens and a few personal effects. Against this estate, Platt

had an outstanding mortgage of $225, which left a total of $8, which was distributed to his daughter, Jennette Freeman.

Of the few estates found for which probate papers exist, only five were solvent and passed some money or personal effects to the heirs, although in the case of Ozias Platt, the inheritance was negligible. These five constituted the upper end of Newtown's free black families socioeconomically, so an examination of what they owned gives an idea of their lifestyle. The other black families in town would have had lifestyles that ranged downward from these five.

The housing enjoyed by the five top families was poor at best. As noted above, Ozias Platt had a house and outbuildings that were valued at only $150, and this included an acre of land that was probably worth $30 to $40. Levi Hall had a house on a half-acre of land that was worth $60 and Cato Freeman's house was worth $60 with a barn that was worth an additional $10. Lemuel Peters appears to have had the lowest value placed on his house of any in our sample. In 1830, its value was given as $15. The largest estate was that of Roderick Freeman, who died in 1868 with a total estate of $877, of which $800 consisted of house and land. His inventory does not separate the house from the land, but most of this value is probably land.

A secondary source of information on black housing comes from early nineteenth-century tax roles. Between 1806 and 1835, eleven free blacks are listed on these rolls and nine of these were former slaves. The values of their houses range from a low of $30, placed on Peggy Booth's house in 1828, to a high of $100 for Caesar Freeman's house in 1824. Most of the listings were for $50 and only occasionally for as high as $100. The values that were put on these houses were undoubtedly lower than the fair market value of the actual house, as is the case today, but regardless of how low the appraisal was, one cannot help but be amazed at the consistently low value of black housing in Newtown.

Again, a comparison with white estates is helpful. The average estate size in all probate inventories for white Newtown residents from 1820 to 1828 was $3,255. This compares favorably with the average of $3,745, which was obtained for white farmers from the 1860 census. This estate size is huge when compared to the average size of $233 for the few blacks who had an estate large enough to inventory.

Some idea of the type of house that is being assessed can be gotten from the tax listings up to 1818. Before that year houses were assessed by the number and quality of fireplaces that the house had. In 1812, for example, Boston Jennings had a house with two fourth-class fireplaces. This suggests a small cottage with two heated rooms and possibly another unheated one.

Fourth-class fireplaces were the lowest of the four allowable classifications. These were generally old and in a bad state of repair.

In that same year, Cato Freeman's house, which was worth sixty dollars at his death, was rated having two third-class fireplaces. It was probably about the same size as Jennings's, but his fireplaces were in better repair. Ned Booth, whose house was valued at twenty-five dollars at his death in 1825, is listed in 1806 with a house that had two third-class fireplaces, but by 1818 his house had been downgraded to having only one fourth-class fireplace. By any standards these were not sumptuous living quarters and yet these houses were still the best of those owned by free blacks in Newtown.

Generally the land holdings of free blacks were small. Of the eleven blacks listed on the tax rolls, eight owned some land. Three owned a single acre, two had holdings of two acres each and two had estates of three acres. Lemuel Peters, who lived on the border with Danbury (later Bethel), was an exception in that he owned nineteen acres in three separate parcels. Two of these were small, at two and three acres each, but the land was fairly valuable at $33 per acre. The largest parcel was fourteen acres and was poorer land, only being worth $6.50 per acre. Although Peters was land wealthy by black standards, he still ranked near the bottom of the white landowning population.

House Furnishings and Clothing

Another way to judge the standard of living of free blacks is by considering the furnishings that went into their small houses. Here again the probate inventories reveal that few furnishings were owned even by those who ranked near the top of the black socioeconomic scale. Every house had at least one chest and most had four. These were used for storage of clothes and fabric goods in houses that had no closets, as was the case for all of the houses of the eighteenth and early nineteenth centuries. All households except one had four or more beds and pillows. The number of beds appears to be a function of the number of children that the couple raised. There was usually one good bed (often a feather bed) that was valued at $3 to $4, and the other beds were simple trundle beds (a bed with another that could be pushed under it) or rope bed, so called because ropes formed the main webbing of the bed (equivalent to our springs), which held up the straw ticking (equivalent to our mattress). The trundle beds were worth from $1 to $1.50 and the rope beds were valued between 20¢ and 40¢.

The only other pieces of furniture that all of the households had in common were chairs and spinning wheels. The number of chairs, as with

beds, seems to be related to the number of children or family members sharing the house. Thus, in the house that was occupied by only one couple there were four chairs, and a house that had several children contained twelve chairs. All of these were straight-backed and wooden, the type that today would be called a kitchen chair. In only one inventory was there an armed chair and a great chair and in this household there were no others.

All of the inventories had spinning equipment, which included two types of spinning wheels. In all but one house, there was a great wheel that was three feet in diameter used for spinning wool. In the one house that did not list a great wheel, there was "one old wheel" that may have, in fact, been a large wool wheel. The other type of spinning wheel, which was found in all but one house, was a smaller double wheel used for spinning flax.

There was little other furniture listed in any of the inventories. Two households had two tables each and two households had a stand or tea table. One had a cellar cupboard and another had a cupboard and a chest of drawers. Only one house had rugs and two of those rugs were described as very old. The general lack of rugs, however, reflects a different attitude toward floor treatment rather than the poverty of the household. Floors were generally left bare in the early nineteenth century rather than covered with anything, including rugs. The rugs mentioned in the inventory may have been used as coverings for chests. That they were very old and of low value reflect poverty.

From this short list of furnishings, it is obvious that free blacks in the early nineteenth century led a Spartan existence. Although it was characteristic of the late eighteenth and early nineteenth centuries for all houses, except for the very rich, to be sparsely furnished, the black households were furnished with the fewest number of pieces that would sustain life with a minimum of comfort. These inventories are for successful households, at the top of the black socioeconomic scale. Life for the average black must have been much harder.

Yet another measure of lifestyle is clothing and, here again, the inventories paint a picture of a simple, hard life, with few material possessions. All of the inventories were for the estates of men so they all listed men's clothing, except for that of Boston Jennings, whose wife had just died and therefore his wardrobe contained a number of pieces of female attire. In fact, Jennings's wife appears to have dressed well for the period. Her wardrobe was valued at over five times that of her husband, but this would seem to be an exceptional case.

As with furniture, there appear to be a number of items of clothing that all of the men had in common, chief of which were stockings and trousers.

Each inventory lists from two to four pairs of stockings. Unfortunately there is no indication of what material these were made or their condition, beyond the fact that they all were wearable. There were from one to four pairs of trousers in each inventory, and here there were occasional descriptions. One pair of trousers was noted as being cotton and another pair was described as being made of nankin or nankeen, a durable brownish-yellow cotton fabric. These descriptions appear to denote a better pair of trousers and only two inventories made any distinctions, suggesting that the most frequently listed trousers were common work pants.

All other articles of clothing varied from inventory to inventory. Even shirts, which one would consider essential, were omitted from one of the inventories and varied from one to three in the others. Some sort of coat was contained in all of the inventories and they varied widely in type. In one case there were two general coats and another of nankin; in another there was one great coat and a jacket; and yet another contained only one overcoat. There were also miscellaneous articles of clothing contained in only one or two of the inventories. Vests, for example, were included in two, and pantaloons or drawers in three others. These last garments were probably underclothes, as they were clearly differentiated from the pairs of trousers.

Most puzzling, however, are boots or shoes. There was only one pair of boots listed in any of the inventories, which was strange considering that footwear is a necessity in this climate. The probable reason for this lies in the fact that the deceased was buried in his finest clothing and, therefore, those clothes would not be included in the probate inventory. This would suggest that for all but one of the estates sampled, the individual had only one pair of shoes. This would also explain the mysterious lack of any shirts in one of the other inventories. The deceased only had one shirt and he was wearing it in the grave.

As with furniture, then, the list of clothing reflects a very lean existence. One wonders what Boston Jennings, whose only shirt was on him in his coffin, did in life when that shirt was dirty. Undoubtedly he went bare shouldered until his wife could wash and dry it and it probably did not get washed all that often, especially in the winter.

Political and Social Life

Politically, blacks were nonentities. While they were slaves, they could not vote within either the town or parish, even if the white population would have let them, since they did not own property with which to meet voting

requirements. Once they were free, the same stumbling block presented itself. In addition, a law was passed in 1818 that formally made it impossible for blacks to vote in town elections. All Connecticut voting statutes subsequent to 1818 continued to state that voting could be done only by free white males over the age of twenty-one, until 1869, when the state ratified the Fifteenth Amendment.

Free blacks did not really compose a society within Newtown. In Connecticut's cities, with their larger black populations, free blacks tended to cluster and live in the same districts of the city. In New Haven as early as 1829, there were even enough blacks to form their own Temple Street Church. Other black institutions that could not be supported in rural Fairfield County also flourished in areas of high black population densities. For example, the election of Negro governors in imitation of Connecticut's gubernatorial elections was carried on from at least 1750 through the middle of the nineteenth century, but the festivities surrounding this practice tended to center in areas where there were many slaves or later free blacks. Thus Hartford and New Haven were the centers of this activity during the earlier years and Derby toward the end.[16]

Central Fairfield County's black population was simply too small and spread out to allow continuous social interactions among its members. Although a celebration of the black governor elections was held in nearby Oxford during the last years of this practice, there is no indication that blacks from west of the Housatonic River ever participated. Even if there had been enough free blacks to support their own church, their poverty would have precluded their ability to sustain it. Instead the portion of the local black population that was inclined to religious practice appears to have been at least partially accommodated within the existing churches.

Newtown's black population was scattered all over town. Of those listed in the 1850 and 1860 censuses, 57 percent were living as laborers in the houses or outbuildings of white farmers. This laborer population appears to have been highly mobile to the point of being transient. They would appear in one census but they were gone by the next. James Purdy, for example, with his wife Elvira and son George, appears in the 1850 census as living with the family of Betsey Gilbert and working as a laborer on her farm. He is missing from the next census in 1860. (Purdy would became the center of the folklore surrounding "Purdy's Station," treated below.)

The transient nature of many black laborers is apparent in the 1860 census. For the first time census takers listed the birthplaces of each member of the family. In the case of many blacks, these lists often form a chronological catalogue of the places where the family had lived. Abraham Pine, for example, was from New York and his wife Mary was born in

Newtown. Their children constitute a living history of their moves. Ann, age nine, was born in Trumbull; William, age five, was born in Bridgeport; Mary, age four, was born in Danbury; and Sally, who was in her first year, was born in Redding, where they were residing at the time of the census.

Among this highly mobile population, social contacts were temporary if they existed at all. The casual acquaintances that might be made with the occasional black neighbor working on a nearby farm would have been dissolved within a year or so, as one or the other laborer moved on to a new farm. Under these circumstances, permanent black social institutions such as the Temple Street Church of New Haven were impossible.

Just as the highly mobile laborer population lived in scattered isolation, so did the town's permanent black residents. There was no black district in Newtown, as there was in the larger towns and cities. The land records show that black dwellings were liberally scattered all over the town, from the Bethel border to the Zoar District on the east side of town. There were two areas where there were small concentrations of blacks. One was above the head of Main Street, where Mount Pleasant Road begins its rise to the summit of the hill. The triangle of land created by Mount Pleasant Road, Currituck Road and Academy Lane was called the "Negro Quarter" in many deeds of the early nineteenth century, but this resulted from the several very small houses there in which black families were living at different times. There was never more than one family living in that triangle at any single time. The second area was the Zoar District along what is now Route 34 from Old Mill Road to Chestnut Hill, but this "concentration" consisted of three or four families spread out among the white farms. They were never dense enough to constitute a "Little Egypt" district.

Easton, on the other hand, had an area that was referred to as Little Egypt, and today's Little Egypt Road in Redding is a memory of that area. The district was actually spread out along Den Road from Route 58 and extending into Weston under what is now the Saugatuck Reservoir. This area has been a subject of independent study by several students from Joel Barlow High School's local history courses, and in the process of locating the various families who lived along the road, they discovered that there were only a few black households scattered among those of poor whites. Of these households, all of them were part of only of three families. The descendants of Sylvanius Baldwin were the largest, occupying several houses. Two other dwellings were occupied by the Coley and Burr families. Given the distribution over a fairly large area, this does not really constitute a black district in the sense it does in the state's urban centers, where high densities of black families, such as found in New Haven, constituted a true Little Egypt district.

Although there was no black residence district, there do appear to have been sections in Newtown's older cemeteries that were used by black families, but even here the sections are not distinct. In the Zoar Cemetery, eight headstones are clustered to the right of the old entrance and these commemorate the black families with the surnames Freeman, Platt and Judson. Most of these stones are for the Cato Platt/Freeman family and they were obviously buried together because they were related, but the presence of another unrelated family suggests that they were buried in that area because they were black. In addition, there is a large area around these eight headstones that exhibits many of the characteristic depressions caused by the collapse of coffin lids under unmarked graves, suggesting the presence of many more burials of people too poor to afford headstones. Is it possible that they were fellow blacks? The appearance of a similar area in the village cemetery with three unrelated families is a further indication of sequestered black burial. There are no other known black burials anywhere else in these cemeteries. If the section of Zoar Cemetery is a black section, it was placed in a prominent position, right at the old front entrance. There certainly was no attempt to hide the black dead in the back corner of the cemetery.

Newtown's black population, like those in all other rural Connecticut towns, was not a distinct society or even an identifiable element within the overall society of the town. They were an integrated part of the town's population without a separate identity. Since they lived in scattered and isolated areas of the town, often near the farm or estate where they or their immediate ancestors had been slaves, they did not interact with each other to any great extent, and therefore formed no distinctly black or African institutions. In their business and social activities they interacted with whites and were little different from the rest of the town's poorer residents. In only two areas were they at all distinct. They always were in the lowest percentage of residents economically, even the most affluent of them, and they were almost always designated as "Negros" whenever the whites with whom they dealt made records of their dealings.

The Society of Free Blacks and Organized Religion

As with slaves, the social structure of free black society is difficult to describe since so little documentation for black social activities exists. There is some data on marriage, however, which also sheds some light on the religious life of free blacks since marriage data gives some idea of the percentage of blacks who participated in the town's religious institutions. In all, thirty-two marriage records were found. Of these, thirteen (41 percent) were recorded

by a man addressed as reverend or elder and we can presume these to be religious marriages made between church members or where at least one of the parties was a church member. Of the remaining nineteen, eleven (34 percent) were married by justices of the peace. The remaining eight were married by men who had no title after their name but who were probably officers of the town.[17]

These figures indicate that slightly over half of the black residents for whom there are marriage records were not part of a formal religious institution. Unfortunately, we are so far separated in time from these non-affiliated blacks that it is impossible to know if they were simply non-practicing or were truly non-religious, i.e., atheistic or agnostic. There is also no indication of how many of Newtown's blacks may have felt that a formal wedding was unnecessary and resorted to a common law marriage without any attempt to make it legal in the established European sense.

Both slaves and free blacks were accepted as members of the prominent churches of the time, the Congregational Church and Trinity Episcopal Church. Although it is not known if they enjoyed the full privileges of membership, such as voting on church matters, they were listed in the churches' vital and baptismal records along with the white members. Comparison of these records for both churches over the first half of the nineteenth century further shows a clear preference for Trinity Church. In the Congregational Church records for this period, the names of only five blacks were found who were also probably members of the church. For Trinity, on the other hand, forty blacks are included in their records. Eight black marriages were performed and twenty-seven deaths and baptisms were recorded.

There are two possible reasons for this apparent preference, at least in Newtown. Reverend Zephaniah Smith, the Congregational minister, attempted to establish the strange ideas of the Sandemanian sect of Presbyterianism between 1786 and 1790. As a result, the membership of that church dropped, through excommunication and resignation, to such a low number that the institution nearly expired. When Reverend Smith was dismissed in 1790, there were only nine members left. At the same time, Trinity Church, under the long and able nurturing of Reverend John Beach, had risen to become one of the most popular institutions in town. This popularity, together with the desperate struggles of the Congregational Church to reorganize and rebuild its membership, may have been the major factor causing such a larger number of blacks to be associated with the Episcopal Church. It also appears, however, that the early ministers of the Episcopal Church were simply more receptive to blacks than were the Congregationalists. The recruitment of blacks and slaves appears to have

been part of the active competition that existed in many central Fairfield County towns between these two most prominent churches. Shortly before his death in 1782, John Beach boasted in his report to the Anglican Church leaders in England that "after proper instruction" he had baptized most of the fifty Negroes in the town.[18]

Beach's remark specifically referred to Newtown, but he was also the minister for the Redding Anglican church and the churches in Redding reflect the same competition as Newtown, although there was slightly greater percentage of baptisms of slaves among Redding Congregationalists. This may have been due to the insistence of the slave's owner rather than the slave's free will. In 1736, for example, John Read insisted on the baptism of all four of his slaves in the Congregational Church. This was undoubtedly done to ensure their spiritual well-being, and it says little about the slaves' spirituality.

Since the number of blacks who appear in the church records is such a small portion of the total number of blacks that this study has identified, it appears that the blacks who enjoyed church membership were in the minority. The majority of Newtown's black population was not very religious, at least not in the sense of joining and being active with one of the town's established churches, and the black population of Newtown was never large enough to support an all-black church, as was the case in Connecticut's cities. Were the county's blacks just not religious or was their non-participation a form of rebellion against European culture, or did they simply hold private religious beliefs? Recent discoveries in one of Newtown's free black's houses have given a tantalizing glimpse that the later possibility, the existence of private religious beliefs, sometimes rooted in African spirituality, may be the answer. This will be examined in some detail below.

4.

Two Case Studies: Cato and Tobias

From all of the data that has been gathered, there is enough on two slave families to compile their history as slaves and subsequently as emancipated blacks. Even with more complete data, there are some big gaps in the surviving information, but regardless of the holes, the biographies of the Cato and Tobias families form two fascinating and contrasting stories of a segment of society that has always been historically silent.

Cato Freedom, Freeman, Platt

According to Newtown's vital records and Cato's tombstone, he entered the world in 1742 as a slave. Virtually nothing is known about the circumstances of his birth: what town he was born in, who his parents were, where they came from or who their owner was. As a result we also do not know the identity of Cato's original owner. Unfortunately, our ignorance of Cato's origins means that we have no idea how far removed from Africa both he and his parents were.

By 1773 his owner was Moses Platt. This was noted on his marriage certificate in the Newtown Congregational Church's records. Three years later, in 1776, when Platt died, Cato appeared in his master's probate inventory valued at sixty pounds, a good price even for a thirty-four-year-old slave in his prime. By Platt's will we know that Cato was inherited by his former master's wife, Hannah, and she most likely gave Cato his freedom some time in the next seven years, for he was a free man by at least 1783.

On October 17, 1773, when he was thirty-one years old, Cato married Dinah, who was also owned by Moses Platt. This was probably a first marriage for him. Although thirty-one was old for any first marriage of the

eighteenth century, marriage opportunities for blacks in central Fairfield County were extremely limited, and it would have taken him time to find a mate. In Cato's case, he only entered marriage when Platt acquired Dinah. The problem of finding marriage partners was not confined to slaves, however. It continued to be a problem for free blacks well into the nineteenth century and indeed is still a problem in rural areas such as ours today where the black population was and is small.

Cato's marriage to Dinah was a short one of only eight months, ending when Dinah died in childbirth. The child survived, but only for six months, dying on January 1, 1775. Cato married again but the marriage date and background information on his second wife, Dorcas, has not been found. Presumably they were married some time before the birth of their first child in 1783 and, since Cato bought land in August of the next year, he must have been a free man at the time of their wedding. It is likely that Dorcas was free as well, but there are no emancipation papers for either of them since both she and Cato were freed before the period in which such papers were formally recorded in the land records.

Cato's last name as a free black followed the pattern of so many other free blacks, using different surnames at different times in his life and for different occasions. This has caused some confusion in trying to identify and separate him from another Cato who appeared in this area at the beginning of the nineteenth century. Our subject appears to have been known locally as Cato Platt. This must have come from the fact that he was "Cato, the slave of Moses Platt," which was contracted to "Cato servant of Platt" or simply Cato Platt. It is this name that appeared in the town's vital records when he died and in the less formal bill of mortality kept by Henry Beers, even though his wife is listed as Dorcas Freeman in those same records.

The first census on which Cato appeared with a last name was in 1800 and he had chosen the name Freedom in obvious celebration of his status. This name also appears on the first deed of land that he received, on the first listing in the town's tax lists and on his will and probate inventory, dated 1818 and 1828, respectively. These are all documents in which he had an opportunity to give or dictate his own name (he was illiterate and could only make his mark) and this, therefore, seems to indicate a preference on his part for being referred to as Freedom.

Later land deeds and tax lists as well as his headstone give Cato's last name as Freeman. This transformation may have come from the fact that Freedom and Freeman sound very similar and those who were recording the name did not hear the "D" when it was spoken. This possibility is even more likely if Cato did not speak clearly or spoke with a drawl. An interesting side

note to the mutations of Cato's surname can be found in the names of his children and grandchildren. His two sons were known as Platt all of their lives and his eldest son's two daughters were also known by the name Platt, but they adopted the middle name of Freeman.

Cato's Real Estate

The year after the birth of Cato's daughter, he bought land. On August 18, 1784, he paid Mary Tousey of Woodbury one pound, ten shillings for a half-acre wooded lot. There was no house standing on the property at the time he purchased it, but from other deed evidence it is apparent that he built a small two- or three-room cottage within a year of acquiring the real estate. This house with two minor additions still stands on the corner of Old Mill Road and Sherman Street in the Zoar area of Newtown.

Cato's real estate holdings increased twice more before his death. On February 28, 1799, he purchased for fifteen dollars an acre from Moses Platt Jr. that was situated immediately to the east of his original purchase. The grantor of this second parcel of land was the son of his former master, so it seems that Cato had settled almost next to the house and estate on which he labored before his emancipation. This tendency to settle close by a former master, often buying land from him, occurred frequently among recently freed blacks. It is quite likely that the former slave also worked at least seasonally on the estate of his enslavement, only this time he was paid a day wage rather than receiving room and board.

The third and last parcel that Cato purchased was acquired on May 16, 1803, for $104. It consisted of another full acre of land with "a dwelling house thereon standing." From later deed references this parcel appears to be located again to the immediate southeast of Cato's other land holdings. The reason for purchasing the extra house is not clear. It was later occupied by one of his sons and still later by his granddaughter, but at the time of its purchase none of his children was old enough to occupy the building, except Dinah, who was twenty. Given the attitudes of the time against women living alone, it is unlikely that she would have moved away from her parents' house until she was married, even if it was just a move next door. More than likely, the parcel of land was simply available and was an obvious addition to Cato's land holdings. Incidentally, it had a house on it that would later be used by other members of the family.

By the time of Cato's death in January of 1828, he had amassed a modest estate of $419.33, which included 2¾ acres of land, a barn and one dwelling house. The other house was occupied by his son, Ozias, and the three other members of Ozias's family (his wife and two daughters). It

may have been deeded to Ozias, since it is not included in Cato's probate inventory, but there is no deed on record in the town clerk's office.

The cause of Cato's death was given as old age and he was, in fact, in his mid to late eighties, which more than qualified the diagnosis. His wife, Dorcas, lived another seven years, dying of the palsy on October 6, 1835. Thus, the first generation of freed slaves had died, but they left a legacy in their three children who had been born free and who continued to dwell on and around their parents' estate.

CATO'S CHILDREN

The oldest of Cato's three children was Dinah, presumably named after his first wife, who was born in 1783.[19] She married Cesar Freeman, the former slave of Cyrenius Hard. Cesar was born in 1781 and was emancipated by Hard on August 3, 1812. It is not certain when he and Dinah were married. It is tempting to assume that they waited until he was freed, and since their only daughter was born in 1815, such a late marriage (she would have been almost thirty by then) is quite likely.

The year after Cesar achieved his manumission, he, like his father-in-law, bought land. He was, however, much less successful managing his estate and from various bits of evidence, it appears that he spent his later years in penury. Cesar bought the parcel of land, which consisted of about two acres with a dwelling house, from Thomas Green for $180. This property was located on what is today Route 34, just north of Cato's estate.

Mysteriously, in 1821, "Dinah Freeman wife of Cesar Freeman" purchased the same two acres of land with the dwelling house "being the same now occupied by said Cesar." This second purchase was made from Abijah B. Curtis and Cyrenius Hard, Cesar's former master, for the seemingly ridiculous price of ten dollars. There are no documents that show how Cesar lost his land and house nor how it was acquired by his former master, but a reasonable guess would be that Cesar lost the property on the foreclosure of a mortgage loan. There is no mortgage in the land records, but such private loans were not always recorded during the early nineteenth century, and the lack of a public record would not have affected the legality of the note of credit to which Cesar attached his mark.

Now without property, Cesar was essentially destitute. At this point it is possible that Cyrenius Hard, who could have been the creditor, acquired the property and contrived to sell it to Cesar's wife, anticipating that she would be better at managing the property than her husband. Since the price for which the property was sold to Dinah was only 5 percent of the original purchase price, the sale must have been charity on the part of Hard and Curtis.

Two Case Studies: Cato and Tobias

Cesar Freeman died on January 7, 1830. This left Dinah a forty-seven-year-old widow with her one fifteen-year-old daughter, Diantha. Three years later, she sold her property to Dinah Judson, another black woman, for $106 and moved back to her childhood home. By this time Cato had been dead for five years and her mother, Dorcas, was probably sick, since she died two years later. Dinah, in fact, may have moved back home to take care of her mother. From the census records we know that she continued to live in the old homestead with various other family members until her own death by apoplexy on April 10, 1861. Her daughter, Diantha, Cato's granddaughter, had predeceased her, dying of consumption in January of 1847 at age thirty-two.

Cato's sons were Levi and Ozias, born in 1791 and 1801, respectively. Both were married but in neither case have the names of their wives survived. By the time of the 1820 census, Levi had married and was living in his own house, although its location is unknown, and Ozias had also married, had two daughters and was living in the house that was situated on the third parcel of land that Cato purchased in 1803. Levi's wife died young at age thirty-two on February 4, 1820. The date of Ozias's wife's death is unknown. The lack of information on these two families is astounding, but it clearly highlights the major problem in conducting research on members of the lower classes and especially those of African origin: they simply did not generate documents and records. This is true even in the case of Cato, whose family is well documented for his time and socioeconomic status.

Ozias was by trade a cooper, a maker of barrels. The cooper was a very important trade in the nineteenth century, since barrels were the cardboard boxes of their time. They served as containers for storing and transporting liquids and solids of all sorts and they were indispensable for domestic use as well as for manufacturers and merchants. Coopering was a skilled trade, requiring a period of apprenticeship. Ozias was, therefore, one of the most highly skilled blacks in the area in the mid-nineteenth century. He continued to ply this trade until shortly before his death by apoplexy at age sixty-three, in December of 1864. He was the last of the second generation of the family, and was only survived by his two daughters.

Ozias's eldest daughter was Jennette Freeman Platt and her younger sister was Charlotte Freeman Platt, born two years after her sister in 1820. Neither of them appears to have married and they lived all of their lives as spinsters in their childhood home. Jennette died on August 14, 1886, followed by her sister eight months later, in April of 1887. Charlotte died with no heirs and left an estate that was sold for a mere $150, about one-third the value of their grandfather's original estate. These sisters were the last of Cato's descendants and they are buried in the Zoar Cemetery next to

the rest of the family, including their father; grandparents, Cato and Dorcas; their uncle Cesar; and their cousin Diantha.

Tobias Freedom, Freeman, Curtis

Tobias was a slave whose life in many respects paralleled that of Cato, but with the difference that, while Cato was fairly successful as a free black, Tobias was a failure. We know almost nothing about his early life except that he was born in 1760. He was born into slavery and, like Cato, it is not known who his parents or first master or masters were. The first record that we have for him was a note made in the town's vital records by Caleb Baldwin in the early 1790s, recording the birth of Tobias's children by Baldwin's slave Phillis. At that time Tobias was a slave of Nehemiah Curtis, who lived in the Zoar District on what today is Route 34.

If Tobias was formally married to Phillis, the record of it has not survived, but they were considered husband and wife in all records subsequent to the birth of their first child in 1782. Phillis was born in Stratford on February 16, 1762. The records of her life before the 1790s, when it is certain that she is a slave of Caleb Baldwin, have been lost. Likewise, the living arrangements for Tobias and Phillis after they were married remain a mystery. It is possible that Tobias lived with the Baldwins and traveled back and forth to Curtis's to meet his work obligations, but we will never know for sure how their married life was conducted during its first decade.

It is highly likely that before Tobias married Phillis, he served as a soldier in the American Revolution. There is only one black named Tobias who lived in Newtown during the time of this study, and all of the records that concern Tobias can be unambiguously associated with our subject, except the war record. It is reasonable to assume that because he would have been about eighteen at the time of the formation of the Continental line in 1777, and since there are no other Tobiases in Newtown at the time, he was the one who served. Unfortunately there is no information about his war record or even when he was discharged. The only record that has survived is the notation made by General Gold Selleck Silliman, the commander of the Fairfield County Militia, that Toby Negro was serving from Newtown in the Continental army in 1777.

According to Caleb Baldwin's notation, Tobias Curtis fathered a daughter, who was born in the middle of 1782, by Phillis, so it can be supposed that he was discharged some time before the end of 1781. This was a year when most of the 1777 enlistees were eligible for discharge. Since it would be another decade before Curtis freed Tobias, it is apparent that his freedom

was not a condition of his service. It is possible that he served in the place of his master, since Nehemiah Curtis does not appear to have served in the war himself, but it is just as likely that he served with his master's permission, for the adventure of travel and a good fight.

Within a decade of his war service, Tobias finally got his freedom. On May 8, 1791, Nehemiah Curtis signed Tobias's emancipation papers and they were filed with the town clerk the same day. Although Tobias's was not the first emancipation in Newtown, his was the first to be formally recorded. It is different from the later emancipations because it was drawn up before the state formally established the emancipation process. It merely contains a short statement by Curtis that henceforth Tobias is free and Curtis "relinquishes all right, title, interest and claim" that he might have on him.

TOBIAS'S REAL ESTATE

Almost two years after he was emancipated, in March of 1793, Tobias, like Cato before him, bought land. The purchase was made from Samuel Beardslee for nineteen pounds and consisted of a small parcel of land "with a dwelling house thereon." Its location was simply given as "standing on the highway a little northwesterly of Nehemiah Curtis' dwelling house." From later descriptions it is clear that his land was located on what is today Route 34, near the intersection with Chestnut Hill Road, and that his former master lived a few hundred feet farther south on Chestnut Hill Road. This was the old road to Stevenson, before Route 34 was widened, straightened and rerouted slightly to the east.

Also in later records, there is a description of the property that shows how small the parcel was. The boundary ran 1.5 rods or 24.5 feet south along the highway and then 6 rods or 99 feet to the east along a smaller road. Including a slight jog in the property line that accommodated his house, Tobias's total holdings amounted to 3,055 square feet or, in more modern terms, 0.056 acres. This is just slightly more than the floor space of the average McMansion of today, and this was just his yard. The house that stood on this lot measured 24.5 feet on a side, yielding 611.3 square feet of living space if it was only one story, which seems likely based on the purchase price of only nineteen pounds.

Tobias's tenure as a landowner lasted only twelve years. He had borrowed money from his wife's former master, Caleb Baldwin, and had trouble paying it back. Therefore, in 1805, Baldwin obtained a court order to collect the debt or to seize Tobias's assets to the amount of $105.59, which would cover the amount borrowed and the cost of executing the court order. Accordingly, the county sheriff approached Tobias, who obviously could not

produce the amount in cash, and seized all of his assets that had any value. These assets amounted to his house and property, which the sheriff valued at $19 (considerably less than the £19 or about $95 that he paid).

It is not known where Tobias and Phillis lived after this financial blow fell. They appear to have remained in the same area, so they may have rented the house back from Baldwin or moved in with one of his neighbors, on whose farm he worked. One hint of their immediate fate after the loss of their land is the census record. In 1800 Tobias is listed as a head of household and he was obviously living on his small estate. The next listing is 1820, where he is again listed as a head of household, indicating that he had rented or made other arrangements to occupy a house. He is missing from the 1810 census. This would suggest that he had moved his family onto a neighboring farm where he was enumerated as part of that farm family.

There is no question that regardless of his living arrangements, Tobias and his family remained impoverished. At the time of his death on September 5, 1825, he is left with an estate that was inventoried and valued at only $46.86. Among the most valuable items that he owned were a brass kettle worth $0.75, three and a half pounds of old pewter valued at $0.50, a blue flannel bed quilt for $0.50, an old gun worth $1.50 and a sixteenth-interest in a fishing place along the Housatonic River valued at $3.

Like Cato, Tobias was known by three surnames during his life. Originally just Tobias or Toby or Toby Negro, he appears in Caleb Baldwin's record of Phillis's children in 1790 as Tobias Curtis, an obvious association with his master, Nehemiah Curtis. He was apparently known as Tobias Curtis to most of his neighbors throughout the rest of his life, for when Henry Beers listed his death in his book of mortality, he used that name. He also bought his small parcel of land in 1793 under the name Curtis. When the land was taken in the 1805 execution to satisfy his debt to Caleb Baldwin, he is addressed as Tobias Freedom, indicating that by the turn of the century he was formally trying to forge an independent identity. Although he was still Tobias Curtis to Beers at his death, his probate papers are all filed under Tobias Freeman.

TOBIAS'S DESCENDANTS

The fate of the rest of Tobias's family is only partially known from a few sketchy records. His wife lived only seven years after they lost their homestead, dying on June 6, 1812, of unknown causes. She was fifty years old at the time.

Only two of their children are known from the records of Caleb Baldwin. The first child, Jennie, was born on August 26, 1782, in Stratford. This meant that she was born as a slave of Caleb Baldwin. Why she was born

in Stratford is somewhat of a mystery. Since Phillis herself was born in Stratford, it is possible that at the time she was to give birth she returned to her mother's residence. It is also possible that Phillis was still living in Stratford and had not yet moved to Newtown. Since Tobias was living in Newtown at the time and it is recorded that he is the father of Jennie, this possibility seems less likely. After her birth Jennie disappeared from the records. It is not known if or when she was ever emancipated, or when and where she died.

A son, Joseph Freedom, was born two years after Jennie, on October 27, 1784. He was born in Newtown, so Phillis was definitely in residence here by then. Joseph was also born a slave of Baldwin's, but he never got a chance to experience manumission. He died on May 6, 1790, at five years old.

There were undoubtedly other children. In the census of 1800 Tobias is listed as a family of five. At this time he was living on his small estate with Phillis and probably Jennie, who would have been eighteen. This would suggest that there were two other children in the family whose names are not known. By the census of 1820 Tobias is listed as a head of household with seven people living with him. Phillis had been dead for eight years and one of those living with him was probably Jennie, although she would have been thirty-eight at the time. From the breakdown in the census record, which included number of people by age range but not their names, there were three other unrelated adults (age over forty-five years) who were living in the same house. Two of the seven, however, were males, one under twenty-six and the other over twenty-six years old, and these were probably unrecorded children.

Even from the few records, it is obvious that Tobias's family died out in Newtown after the first quarter of the nineteenth century. He, like Cato and so many other former slaves, has no known descendants living in this area today.

Both Cato and Tobias led different lives, one relatively successful and the other fraught with poverty, but they also shared much in common. Their fates were typical of many of the area's slaves, at least the more fortunate ones. A large number of the central Fairfield County slaves, however, literally disappeared. They led lives that were so undistinguished and without wealth that they generated no records at all. As a result, some of this profile of the free black population is distorted, as it is based upon those men and women whose lifestyles were sufficient to produce records, even meager ones. The forgotten free blacks will remain invisible even though there are many individuals in this segment of the early American population who are ancestors to this area's modern black population. To their descendants they will always remain frustratingly unknown.

Slave Archaeology: A Window into African American Spiritual Life

More documentary information has survived on Cato and his house than on any other black site in central Fairfield County. Although the house has been modified, these modifications were mostly modern and they have left the fabric of the original building largely intact. In addition there have apparently been only minor changes in the landscape of the back and side yards. This became an unprecedented opportunity to conduct archaeological excavations on an African American site, an area in which Northern archaeologists are just now becoming interested and involved. In addition, the current owners of the house, Mike and Pam Davis, have developed an interest in its history and that of its black occupants. As a result, they were enthusiastic when I approached them with a proposal to dig up their backyard as part of a field school for my anthropology students. We had hoped to recover a representative sample of late eighteenth- and early nineteenth-century African American material culture that could be compared with that of a contemporary European household. That archaeology is still ongoing, but in the preliminary survey of the house we made several discoveries that have shed new light on African American religious and spiritual practices.

The House

As part of the initial survey and mapping of the house and grounds, we took careful measurements of the house itself. This structure would be

classified by an architectural historian as a story and a half, or in modern terms, a Cape Cod house. Usually these houses are rectangular, with the main entrance in the long side, which is parallel to, and facing the road. The standard building unit for colonial and early American houses is sixteen feet, supposedly derived from medieval England, and is based on the distance necessary to accommodate a yoked team of oxen. The colonial house then usually consists of measurements that are some multiple of this basic sixteen-foot unit.

Cato's house was unusual in that the original structure was square and measured twenty-four feet on each side. It also had its entrance on the gable end of the building, which was situated perpendicular to the road. Very shortly after the original building was constructed, a kitchen wing was added to the south side that extended sixteen feet from the wall and was twelve feet wide.

The twenty-four-foot measurement was significant because in West Africa the standard building unit was twelve feet. The use of this standard in African American buildings was first noted by the archaeologist James Deetz in his reporting on the Parting Ways site in Plymouth, Massachusetts. He has interpreted the presence of this measurement in these sites as persistence of a basic African way of thinking that endured and survived slavery.[20] Coincidently, the surviving description of Tobias's small house also includes a measurement of a house that was square and twenty-four and a half feet on a side.

In addition to the measurements, the framing was also distinctive. Shortly after they purchased the house, the Davises re-sided it and in the process exposed the post and beam framework on which the rest of the house was suspended. The post and beam style of framing was a standard building practice of European houses before 1825. The usual pattern is to have four primary posts along the front (long side) of the house, one in each corner and two supporting the beams that run to each side of the chimney stack. The side of the average story-and-a-half house was shorter and had only two posts, one each in the front and rear corner. Cato's house was distinctive in that it had three posts along the front and sides and these were spaced with the center post roughly equidistant from each of the corner posts.

It is unclear at this point how significant this difference in framing is. The three-post pattern for the front of the house is occasionally encountered in central Fairfield County and it constitutes a regional difference in construction that may have been the work of one or two local builders. In these cases, however, the side of the building is still shorter than the front and has only two corner posts. These observations constitute research in progress and more houses that were built by free blacks need to be found and

examined in order to establish the significance of the framing differences. As with all research in this area, it is hampered by the few African American houses that have survived. This is a result of the usual poverty of the early owners, which kept them from properly maintaining the house, and from the general lack of interest in houses of the rural under classes, which meant that they were not seen as worthy of preservation as were the stately mansions of the same period.

The Spirit Mark

In October of 2004, Connecticut held its first Archaeological Expo. A featured speaker at that event was Dr. Warren Perry of Central Connecticut State University, who along with Jerry Sawyer and Janet Woodruff has formed the Africana Center at that university. As part of his presentation, Dr. Perry discussed the incidence of spirit marks that were made by slaves and free blacks in dwellings and on personal items. His verbal description of these marks was not specific, but it stimulated us to search the site for anything that could qualify as such spiritual artwork.

As we carefully examined the stonework of the basement, Diana Lynn Messer was the first to see a carving on one of the cut stones of the chimney stack. The stone was at eye level on the chimney's southeast corner, and it appeared to be a large cross or X with the upper left element distended over twice the length of the others. There was another smaller chisel mark perpendicular to that left element and a later photograph taken under oblique lighting revealed an almost perfect circle at the element's end.

Research indicated that marks of this type had been found on colonoware, a type of pottery long associated with African and American Indian sites in the South. Frequently, bowls with the mark on the exterior or interior of the bowl bottom had been found in submerged contexts in swamps and lakes in close proximity to slave sites, obviously the result of some ceremony. In addition similar marks had been found on spoons and some other personal items.[21]

The mark has been interpreted by Robert Ferris Thompson in his pivotal work on West African art as a cosmogram, a diagrammatic representation of the universe, as perceived by the Bakongo of West Africa.[22] The horizontal arm represents the separation by water of the world of mortals and that of the ancestors; hence the placement of the pottery bowls in underwater contexts. The progression in time is counterclockwise from the sunrise to sunset and then to the underwater ancestral world. It also represented the progression of the individual soul

from birth to death and then into the post-death world of the ancestors. The use of this diagram, or the modified diagram as found in Cato's basement, opened up channels of communication with ancestors who continue to be concerned with the working of the mortal world and thus it would afford protection to their descendants.

Bakongo Cosmogram (after Thompson)

The appearance of this mark in the basement was obviously a remnant of African thinking that Cato had learned from his parents or possibly firsthand from elders or shamans if he was raised in Africa. Unfortunately, our ignorance of Cato's origins, especially whether he was a first generation African or several generations removed from his African roots, seriously hampers our ability to understand exactly what this mark meant to him. Was it something that he understood in its cosmological context as an expression of his personal belief system, or was it a symbol, stripped of its meaning but used to ensure good luck as we might use an Egyptian cross or ankh as a piece of jewelry to ensure good fortune? Subsequent discoveries clarified Cato's mindset somewhat, but did not completely answer this question.

The Concealment Shoe

While attending to some repairs in the crawl space under the kitchen addition, Mike Davis discovered a single male shoe, well worn and missing

its heel. It had been tucked up under the kitchen floor in an almost completely inaccessible location and it was obvious that it had not simply been lost, but rather placed there intentionally.

Photographs of the shoe, and subsequently the shoe itself, were sent to Adrienne Saint Pierre, the curator of the Fairfield Historical Society, whose specialty is historic clothing. She identified it as a late eighteenth- or early nineteenth-century male shoe. Further research revealed that it was a type of shoe known as a brogan and that these inexpensive shoes were mass-produced in Massachusetts and shipped to the New Orleans slave markets. Since the shoe was so well worn and since the kitchen addition had been built soon after the house itself, the shoe must have belonged to the only adult male in the household at the time, Cato, and he must have worn it for a long time before the house was built. This would have meant that he had worn the shoe while he was still a slave, making it the first piece of slave clothing that has been recovered in the county.

Adrienne also identified the shoe as a "concealment shoe." These shoes were hidden in inaccessible areas of the house shortly after construction and were never meant to be seen. Only one shoe is hidden and it can be male, female or often a child's. It is almost always well worn. The custom is much better documented in England, where cases of concealment date back to the thirteenth century and as recently as 1935. June Swann has been collecting instances of concealed shoes sine the 1950s and has amassed a large database of shoes found throughout Europe but especially in the British Isles. She is convinced that these shoes, and occasionally other garments as well, were meant to prevent evil from entering the house.[23]

A shoe is the most intimate piece of a person's apparel. As it is worn, it conforms to the shape of the wearer's foot and it also picks up patterns of wear that are conditioned by the idiosyncrasies of the person's gait. Therefore the shoe can be seen as picking up the spirit of the owner. The concealment shoe, imbued with the spirit of the wearer, then watches over and protects the residing family. These concealments are also often made in places where there are openings in the house, such as between the walls near a window frame or behind the stones of a chimney stack, so they will be effective in guarding against the entrance of bad, malicious or evil spirits.

The most revealing aspect of Mike's find was that it was an English tradition that was executed in the house of an African. The find suggests that Cato picked up this superstition from his master's family, which further strongly suggests that the relationship between master and slave during Cato's earlier life must have been fairly close. One of Swann's documented cases, which was dated to 1935, relates that a son came upon his father concealing a shoe in their newly constructed house. The father would not

explain what he was doing and seemed embarrassed by his discovery. If the practice was so private and was meant to be forever hidden from view, how was Cato privileged to have seen it and understand its meaning unless there was some closeness between slave and master? Further, Cato believed strongly enough of the efficacy of the practice to make it part of his own thinking and the way that he perceived the spirit world.

The next surprise came on an afternoon when the shoe was being examined carefully under oblique lighting. The upper part of the shoe, about halfway between the holes for the laces and the sole, showed a very light mark: a compound of two straight lines perpendicular to each other that had been drawn on the leather with a metallic lead pencil and a straight edge. This was the familiar cross or X of the basement, complete with the elongated upper left element (but without the circle). Cato had duplicated the spirit mark that he had carved on the stone of the chimney stack on the concealment shoe, and so combined a European spiritual belief with one of Africa, both relating to the spirit world. This is the first time that the conflation of the white and black spiritual practices has been documented in this area and it opens a new window on the spirituality of African Americans as they adapted to a predominately European world of captive service.

These discoveries also tell us something about the religious nature of free blacks. Cato appears in the Congregational Church records as having been baptized in 1770 and married to Dinah in 1773. Both of these records were written when Cato was still a slave to Moses Platt, but there are no church records for him after he was emancipated. There are no baptismal records for his children or grandchildren, or any marriage records for his descendants. It was not unusual for masters to pressure their slaves to be baptized for the sake of their soul. Thus baptism and even marriage in the church for slaves was not necessarily volitional, and once free, all connection with the church was often severed, as seems to be the case for Cato. It is unfair, however, to assume that unaffiliated blacks like Cato were atheists; rather their religion was manifest in a series of personal spiritual practices.

Everyone shares a certain basic level of religious belief. This level is frequently considered superstition and is often scoffed at by those who prize themselves on their high level of education and ability to approach the world in a scientific, rational matter. Yet it is common for these same people to feel uneasy or vaguely anxious when they have spilled the salt or broken a mirror. Many well-educated individuals will be seen surreptitiously taking a pinch of the spilled salt and throwing it over their left shoulder to ward off the impending evil. These basic religious inclinations are a way in which we constantly cope with an often-capricious world in which accidents happen for seemingly no reason.

Slave Archaeology:
A Window into African American Spiritual Life

If this is true of the modern scientifically educated world, it is easy to see that this was even more important in the world of two hundred years ago that did not have scientific explanations for sudden disasters and unfortunate occurrences. Here, in the world of superstition, are the essential spiritual beliefs and practices that enabled Cato to cope with his world and protect his family from misfortune. These beliefs were personal, internalized and, as is obvious from Cato's case, derived from the cultural milieu in which the individual was raised. For most slaves and free blacks this cultural milieu was predominately European, but as is becoming increasingly clear from recent research, the African cultural milieu was not lost, even after several generations of intense European cultural contact. It survived and was manifest in building techniques, basic religious beliefs, worldview and in countless other ways that have not survived the illiteracy of the black world of the eighteenth and early nineteenth century.

Images of Slave Life in Connecticut

A typical emancipation document, as recorded in the town's land records. This one was for Julius Cesar, a slave of Ebenezer Beers, who was emancipated in 1796. *Courtesy of the author.*

To all people to whom these presents shall come Greeting Know ye that I W. Sarah Nichols of Newtown in Fairfield County for the consideration of fifty dollars received in hand of Titus a free Negro of the Town of Fairfield to my full satisfaction and Content have granted bargained & sold & by these presents do grant bargain sell & convey unto Titus a Free Negro his Executors administrators & assigns one certain Negro girl Named Time aged about thirty one years to have & to hold the s.d Negro girl to him the s.d Titus a free Negro his Executors & assigns for and during the Natural life of the s.d Negro Girl & furthermore I the s.d Sarah Nichols do for my self & hiers warrant the s.d Negro girl to him the s.d Titus a Free Negro against all just claims & demands whatsoever In witness whereof I hereunto set my hand & seal this 1.st day of March A.D 1804

Witnesses

Joseph Nichols

Sarah Nichols W [L.S.]

A rare bill of sale that was recorded in the town land records. In this document, Sarah Nichols sells her slave girl Time to Titus, a free black of Fairfield, for fifty dollars. The year was 1804. Titus married Time but never emancipated her, making him one of the few men to actually own his wife. *Courtesy of the author.*

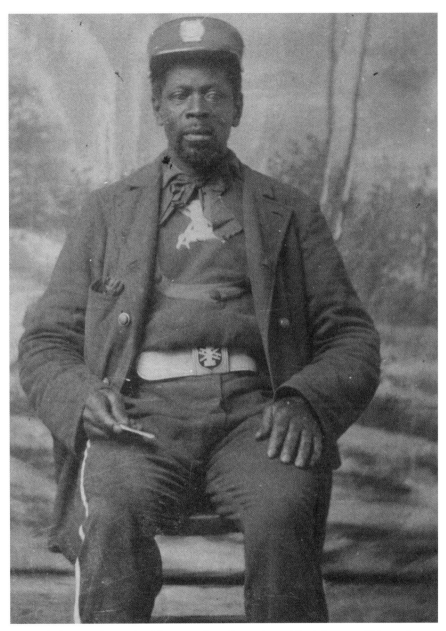

The only known photo of a Newtown slave descendant. Alfred Jefferson Briscoe, known as Jeff around town, was mildly retarded and declared incompetent by his father in 1856. Regardless, he was very popular in Newtown, where he drove hotel guests back and forth to the railroad depot. When he died in 1898, a grand monument was placed on his grave. He is the only black included in J.H. Beer's massive *Biographical Record of Fairfield County*, published in 1899. Jeff was the grandson of Alexander, the slave of Captain Nathaniel Briscoe. *Courtesy of the Newtown Image Archive of the Newtown Historical Society.*

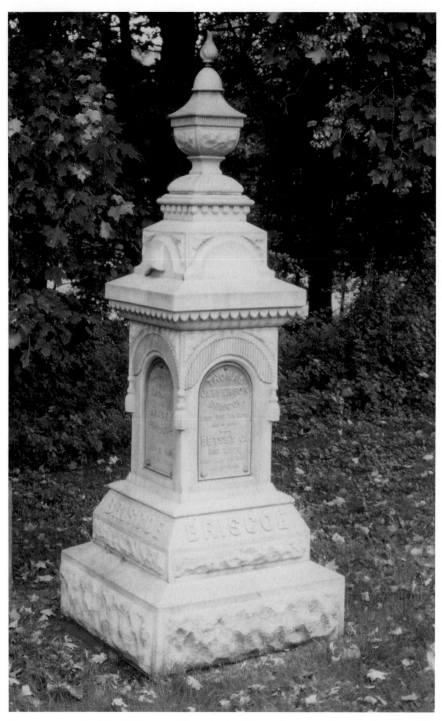

The monument to Alfred Jefferson Briscoe in the Village Cemetery. The panel on the right face is for his parents, Betsey and Thomas Jefferson Briscoe. *Courtesy of the author.*

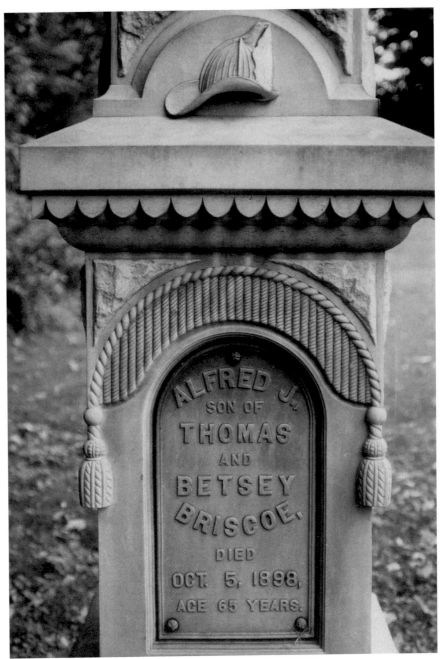

Jeff's panel on the left face of the monument, with a small fireman's helmet molded into the metal above. His first love was the Newtown Hook and Ladder Co., of which he was a long and proud member. Since the fire helmet is cast into the main fabric of the monument, the entire monument had to be made especially for Jeff. It was not some stock model with a specially cast name plate. *Courtesy of the author.*

The House of Cato Freeman/Platt, built circa 1784. It still stands at the intersection of Old Mill Road and Sherman Street. *Courtesy of the author.*

The black section of the Zoar Cemetery, located just to the south of the original entrance. Cato Freeman/Platt and his family are buried around the cedar tree. *Courtesy of the author.*

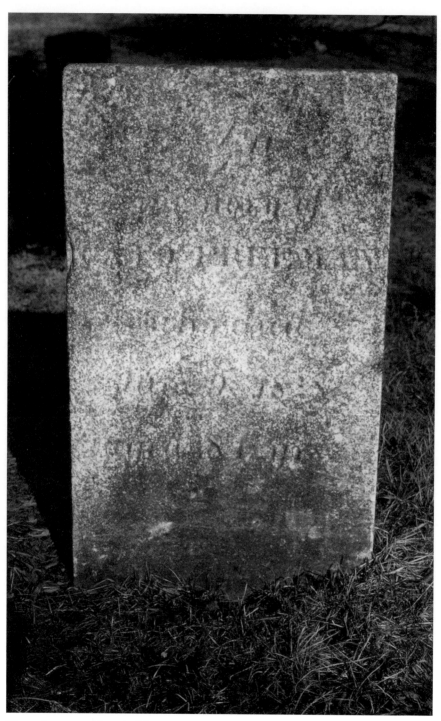

The well-worn and bare legible headstone of the former slave Cato Freeman, who died in 1828. *Courtesy of the author.*

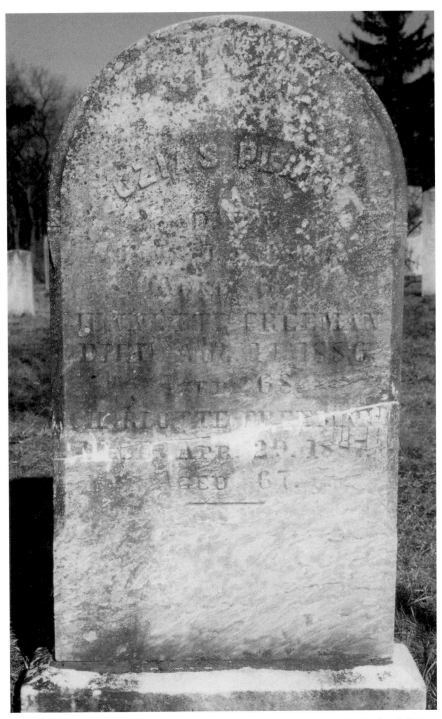

The headstone of Cato's son Ozias. This stone also commemorates the death of Ozias's daughters (Cato's granddaughters), Jennette in 1886 and Charlotte in 1887. *Courtesy of the author.*

The frame of Cato's house. This was revealed when the house was recently re-sided and it shows clearly the three posts across the side. *Courtesy of Mike and Pam Davis.*

The spirit mark. This mark was clearly carved on one of the stones on the southeast corner of the chimney stack in the basement of Cato's house. It is identical to marks found on pottery and other special household items associated with slave sites in the South. *Courtesy of the author.*

This well-worn concealment shoe was found between the floor joists of the kitchen addition of Cato's house. The secreted shoe was an English practice, but the spirit mark on the shoe is African. *Courtesy of the author.*

The upper portion of the shoe. This close up shows the dim but obvious spirit mark, made with a piece of metallic lead and a ruler. *Courtesy of the author.*

This house was already on the third parcel of property that Cato purchased, and it still sits above the house that Cato built in 1784. This house was constructed by a European builder and shows distinct differences from Cato's. It became Ozias's home once he was married. *Courtesy of the author.*

Black dwellings tended to be modest and small, and as a result they often did not survive. This is one of the exceptions. It belonged to a free black named Erastus Quackenbush (or simply Bush) and it is located at the head of Main Street, just west of the entrance to Currituck Road. The triangle formed by Currituck Road, Mount Pleasant Road and Academy Lane, in which this building is located, was sometimes called the "Negro Quarter" because of several black families who lived here at different points in time. *Courtesy of the author.*

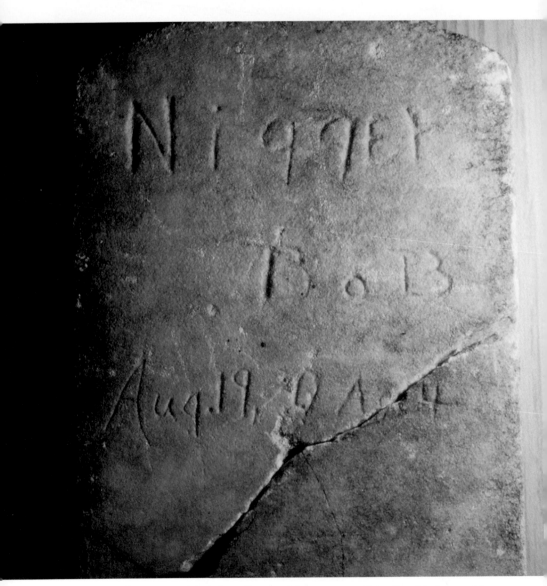

A headstone for a young black boy discovered in a stone wall by Jim Morley, on his Huntingtown Road property. It was lightly inscribed into an old footstone. The crude inscription reads, "Nigger Bob, Aug. 19, 28 Age 4." It had to be photographed under oblique light to read even this much. Beyond what is given on the headstone text, the identity of the boy is a mystery. *Courtesy of the author.*

6.

Blacks in the Revolution

*I*t is no coincidence that directly after the Revolutionary War, the move to abolish slavery gained momentum in the North with such force that the institution was moribund by the beginning of the nineteenth century. There was a clear contradiction in Englishmen fighting to establish their own freedom while owning slaves. The phrase that "all men are created equal by their creator," which appeared in the Declaration of Independence and countless other documents of the time, rang hollow when Africans were declared to be inferior and then forced into servitude. This conflict of conscience became especially strong as many slaves and free blacks took up arms in the cause of that freedom.

The irony of slave captivity during an armed struggle for freedom was explicitly recognized by the county's slave population when they actually memorialized the General Assembly for emancipation. Under the leadership of Prime—a slave of William Samuel Sturgis—and Prince—a slave of Steven Jennings—the slaves of Fairfield and Stratford petitioned the General Assembly on May 11, 1779, asking to be allowed to "rejoice with your honors in participation of that inestimable blessing freedom."[24] A similar petition was submitted in Massachusetts at about the same time. Both petitions were rejected, but the feeling that slaves should be free was well planted and growing.

The need for abolition was felt so strongly in Vermont that when they formulated the state's constitution in 1777, they formally forbid slavery in the state, making them the first to do so. They were followed by Massachusetts, which abolished slavery just after the war ended, in 1783, and by Rhode Island a year later. Connecticut did not go quite that far, but in the same year that Massachusetts liberated its slaves, legislation was introduced in this state that provided for gradual emancipation. All slaves born after March 1, 1784, would automatically be emancipated by age twenty-five. Slavery had not been abolished but the mechanism was in place to gradually phase it

out and by the third decade of the nineteenth century there were virtually no slaves in central Fairfield County.

That the very people who had been oppressed and forced into servitude took up arms to help free their oppressors is one of the great paradoxes of the Revolution. Many slaves served as replacements for their owners, often for the promise of emancipation at the war's end, but many served with no such promise. Free blacks had less reason to take up arms, but they must have felt that life with free New Englanders was better than life under the British. Unfortunately it is difficult from this distance in time to divine what their varied motives were. They did not write essays justifying their actions, as did their American neighbors. If they expressed an opinion it was never deemed worthy of being written down and preserved. In all fairness most opinions of common whites were also rarely recorded unless they were from men of distinction, but this silence makes it almost impossible to answer the question, why did they fight?

The Record of Local Black Soldiers

The fact of their fighting, however, is beyond dispute and many of their records have survived. Several of these records contain stories of bravery and heroism that deserve to be revived for modern Americans and especially for their black descendants. Fortunately, there are several men who are conducting the research to perform that resurrection. One scholar who worked at the time of the American bicentennial, David O. White, produced in 1973 a pioneering monograph titled *Connecticut's Black Soldiers 1775–1783*.

After describing the overall accomplishment of the state's blacks in the Revolution, he appended a list of 289 black soldiers, culled from local histories and other state documents. Because of the frequent difficulty in distinguishing blacks unless they were so labeled, he felt that this list understated the number that had actually fought and that the number should be closer to 400.[25]

Few of these, however, were from central Fairfield County. From Newtown's military records, we know that five or possibly six of White's potential four hundred black soldiers came from this town. Redding has only three, and none have been identified for Easton and Weston. Trumbull has one well-documented black soldier, Nero Hawley, but no others have yet been found. It is anticipated that as research proceeds, a few more will be added to this list, but the blacks already identified give us a glimpse into the African Revolutionary experience.

Slaves being under arms to defend the town or colony during times of war, or even being in the local militia, was a difficult problem for most colonial officials. Although "Indians and Negroes" were ordered to train with the "Train Band" or militia in the earliest years of all the New England colonies, Connecticut passed a law in 1660 that provided that "neither Indians nor negar servts [servants] shall be required to Traine, Watch, or Ward."[26] The reasons for exempting blacks from the militia are not given with the law, but speculation from a number of sources suggests that the colonial fathers felt that arming slaves was dangerous.[27] Given the low numbers of African slaves in Connecticut during most of the colonial period, this speculation does not seem reasonable. It is more likely that the colonial fathers felt that membership in the militia and the opportunity to defend one's town were the prerogatives of citizenship. Indians and blacks were not citizens.

The law provided that blacks did not have to train, but it did not prohibit them from enlisting in a militia company. Such enlistment during time of peace may have been discouraged, but during periods of war they were accepted. In the earlier colonial wars, therefore, blacks can occasionally be found on muster rolls, though not in any great number. For the central county, however, there do not appear to be any blacks serving in the military before the Revolution. Since, at the time of the French and Indian War, the slave and free black population of Newtown was only twenty-three (and a fraction of that for Redding, Easton and Weston combined), this lack of participation is not surprising.

From the meager documentation for black military service, the reasons for the enlistment of the central county's nine known black Patriots of the Revolution are not clear, but from the motives given for blacks from other towns, a range of possibilities may be suggested. The most compelling reason to serve was freedom. Although there were no laws that made freedom automatic for a slave veteran, it was a frequent understanding between master and slave that the slave would be emancipated at the end of the war. This was especially true if the slave served in place of his master after that master had been drafted to join the Continental line. In another arrangement, the slave would be freed after he turned over to his master the bounty he received for enlisting, in effect buying his own freedom.

This does not mean that some slaves did not serve out of honest patriotism, for the sheer adventure of fighting or simply to get away from the tedium of farm work. Freedom, however, was clearly the primary motivation and this can be seen in such celebrated cases as Nero Hawley from Trumbull, about whom E. Merrill Beach has written so glowingly.[28] Hawley served from April of 1777 to April of 1781 as a soldier in the Continental army, during which

he fought in every major engagement. In November of 1782, a year and a half after his discharge, his master, Daniel Hawley, emancipated him. This pattern was virtually identical for Newtown's veteran slaves, except that we frequently do not know the date of their emancipation.

All of the blacks who served from the central county served in the Continental army. There were none we know of who answered a local alarm, such as that for the Danbury Raid in 1777 or the burning of Fairfield in 1779; nor were there any who served in either the militia or state levies that marched off for short-term engagements and guard duty along the coast. The reasons for this are obvious. Blacks were not part of the militia and therefore they could not be detached for a state levy and, with one exception for the Danbury Raid, our black soldiers were serving with the main army when the two local alarms were sounded. They were not able to participate in the response to them because they were not in this area.

The one tantalizing exception is Ned, the slave of Samuel Smith of Redding. For reasons that will always be unclear, when the British marched north to burn the military stores in Danbury on April 27, 1777, Ned was in Major Daniel Starr's house on what is now the corner of Main and Boughton Streets in Danbury. According to the diary of Archibald Robertson, who was serving as an engineer for the British army, "When we entered the Street 7 Daring Rascals fired at us from a house that flanked the street we were drawn up in. Two Companys of the 15th [Regiment] Attack'd them and put then to death, Burning the house."[29] From a later deposition one of the officers who attacked the house claimed that when he entered the house there were several men there, including a "negroe" who, after he had been run through with the officer's sword, rose up and attempted to shoot his assailant, in reaction to which the officer decapitated him.[30]

In January of the next year, Samuel Smith confirmed that the Negro who was killed at Starr's house was Ned, and he requested reimbursement for the loss of his property. His account of Ned's service and death is worthy of quoting. "When the enemy of the United States of America made their incursion into the County to Danbury the sd Negro being a very zealous friend to the American Cause turned out and went to Danbury to oppose the British troops and then and there bravely fought and opposed sd troops till he was killed by the Enemy."[31] If Smith's account is accurate and not simply pumped up to ensure compensation, Ned's actions were truly patriotic. He was not only among the first to die defending the stores at Danbury but was also probably the first black casualty from this area. These actions along should mark him as a local hero, a man who fought and died so that his owner could be free.

Other Black Veterans

As for the other local black war veterans, the ones about whom we know the least are Jack Negro, Sampson Negro and Toby Negro from Newtown. All three are included on a long list of men who were serving in the Continental army from Fairfield County.[32] On this list they are designated as coming from Newtown and serving in a regiment commanded by Colonel Beardsly. Beyond the fact that they were serving with five other Newtown residents in the same regiment, there is no other information on their service. Even more disappointing is the lack of information concerning where they fought and wintered. At best we can assume that they were fighting with the main body of the army, wherever it was. It is not even certain how long they served.

Although their war record is murky, some aspects of their civilian lives are known. It is probable, for example, that Sampson Negro was the slave of Abial Botsford and is the Samson mentioned in Bostford's 1774 probate estate inventory valued at five pounds. This is among the lowest value of any slave in the area and it might indicate that he was a young boy at the time of the inventory, but five pounds is still low for a boy. It is a value usually given for an old man, beyond his prime labor years. These possibilities highlight the frustration of working with a group of people for whom there is so little data.

Toby Negro is probably Tobias, later known as Tobias Curtis and still later as Tobias Freeman or Freedom. If this identification is correct, he was the slave of Nehemiah Curtis and was born in 1760, making him eighteen years old at the time he enlisted. Since he was not freed by his master until 1791, this Toby did not obtain his freedom as a direct result of his war service. Here again, however, we are at the mercy of little information.

Jack Negro is quite likely Jack Botsford, who was known to be serving in the Continental army as early as 1777. Botsford and another Newtown black, Bristol Caesar, served together and we have a good deal information on their war record, although we have almost no personal data on either.

Both Botsford and Caesar enlisted within a month of each other in the spring of 1777. They were then assigned to the second company of the Eighth Regiment of the Connecticut line, which was commanded by Colonel John Chandler, one of Newtown's most prominent citizens. Botsford served until January 1, 1780, when he received an honorable discharge. Caesar, on the other hand, is listed as having deserted on November 9, 1779, but as having rejoined a short time later. The term deserter does not necessarily imply cowardice or abandoning his comrades. Revolutionary War muster rolls are notorious for listing a man as having deserted when he simply had not

been accounted for at a daily muster. Reasons for this were many, including being out on detached duty. Since he is listed as rejoining, a simple mistake in record keeping, something for which armies of all ages are known, is the likeliest reason for his deserter designation. We are not sure when he was mustered out, but he was still receiving supplies from the town in 1780, indicating that he probably finished his enlistment term, which would have been over at about the same time as Botsford's.

Since we have a fairly good account of the engagements in which the Eighth Regiment of the Connecticut line took part, we can piece together the probable war records of both men. The first major engagement after their enlistment was at Germantown, Pennsylvania, in October 1777. This battle was an attempt to recapture Philadelphia after it had been taken by the British two weeks before. It was a failure and led to a general retreat into the infamous winter quarters at Valley Forge.

Botsford and Caesar survived the rough winter of 1777–78 and marched out with the rest of the regiment in June of 1778 to cut off the British as they abandoned their position in Philadelphia and fled across New Jersey. The American army caught up to them just outside of Monmouth, which gave its name to the battle. They were again defeated, this time as much by the incompetence of General Lee and the heat as by the British.

The Eighth Regiment took part in no other major battles that year and by November they were headed again into winter quarters, this time in Redding. Botsford and Caesar were part of the encampment that is commemorated today by Putnam Memorial State Park, although they were in the easternmost section of that encampment under what is today West Redding and not in the region of the park. Although that winter was much milder than the previous one, life in camp would have been more difficult and frustrating for the Newtown men since they were so close to the warmth of home but were required to stay with their regiments.

The only major engagement that involved the regiment in 1779 was the storming of Stony Point on July 15, under "Mad" Anthony Wayne. The fort's capture was of minor value to the war except as a boost to the army's morale after suffering repeated defeats. The dashing bravery of the troops under Wayne was a source of stories that became legends and Botsford and Caesar were silently part of those stories.

The winter of 1779–80 was spent at Morristown, New Jersey, where the regiment arrived in the first week of December. Fortunately for Jack Botsford, he only had to endure about four weeks of what was to be the coldest of any of the Revolutionary winter encampments. On the first of January 1780, he was given an honorable discharge and he headed home. The date of Bristol Caesar's discharge is unknown, but he may have

lingered on through the winter encampment since he is listed as receiving supplies from Newtown in 1780, and he would not have received them if he had left the army early in the year.

Of the postwar fate of Jack Botsford, we know nothing. He drops completely from the Newtown records and it must be presumed that he won his freedom and left town to settle elsewhere. About Bristol Caesar we know a little more. Although it is not known when he was emancipated or who his master was, we know that he settled on Toddy Hill Road and, according to the records of the Newtown Sheep Company, he served as the town shepherd for at least the year 1824.[33] Unfortunately nothing more is known about this man who experienced some of the truly great and trying moments of our nation's most important war. He is not even mentioned on the bronze plaques honoring Newtown's veterans in front of the Soldiers and Sailors monument, although Jack, Sampson and Toby all made it. (Strangely, on the memorial plaques, these three men were given last and middle names that bear no relation to any names that they had in life.)

One other Newtown black veteran deserves mention even though was born in Woodbury and enlisted from that town. Cummy Simons's service record has not survived in the conventional listings, but it is known that he applied for and received a pension in 1818. At that time he is listed as a resident of Pennsylvania, but shortly afterward he moved to Newtown, probably to live with his son, Cummy Simons Jr., who was here with his wife, Patience Booth. He lived and worked as a farmer and butcher in Newtown for the rest of his life. Dying on May 9, 1833, at the age of 105 years, he left descendants who continued to be part of the Newtown black population until well after the Civil War.

Besides Ned, there are two other black veterans who are known to have served from Redding: Negro Jack and Negro Ned. Their war records have survived, but there is nothing known about them personally. Both men enlisted in the Fifth Connecticut Regiment in 1777. Jack took part in the Battle of Germantown on October 4, along with Newtown's Jack Botsford and Bristol Caesar in the Eighth Regiment. Unfortunately, Negro Jack was captured by the British. This might have spared him the harsh winter encampment of his fellow soldiers but he is listed as rejoining his regiment sometime in November, either having escaped or been released.

He suffered through the Valley Forge winter and participated in the fighting season of 1778, during which he fought at the battle of Morristown. That next winter (1778–79), he wintered in Redding, being part of the "middle encampment" that was located on Limekiln Road near the intersection with Whortleberry Road. Again he endured the boredom of a winter camp until May 6, 1779, when he deserted the regiment. The reason

for his desertion is a mystery, as is the rest of his life, for there is no record of him after his disappearance from the ranks.

Ned's war record was the same as Jack's except for being captured. He also fought at Morristown on June 28, 1778, and seventeen days later he is listed as having died. His death, coming so close to the battle, suggests that he was wounded, but there is no cause of death given. Once again the frustrating lack of records leaves a major hole in the record of a man who very well may deserve to be considered a Redding war hero.

As with Newtown's black soldiers, it is unknown if Ned and Jack were slaves or free blacks when they enlisted. These men also do not appear in the lists of slaves and free blacks that have been compiled for Redding. So there is nothing known about their lives prior to enlistment, their families, their relationship to other citizens of Redding or, in the case of Ned, his postwar fate. There is always the possibility that some presently unknown document may be lurking in a Redding attic that will share some light on these men, but the possibility is remote. These men, like so many of the area's slaves and free blacks, will undoubtedly remain in the twilight of the county's history.

7.

Abolition and the Underground Railroad: Blacks and Local Folklore

*I*t is surprising that for all of Connecticut's zeal to create the legislative mechanism that would ultimately lead to the end of slavery, the citizens of the state and especially Fairfield County would be so hostile to the cause of abolition, occasionally to the point of violence. This may be the result of the abolition movement itself, which relied heavily on outsiders to promulgate the message of abolition and often did so with a repulsive zeal. The end of slavery in Connecticut was accomplished by its own citizens without outside pressure or influence, but Yankees have never liked outside interference, and they have always been wary of zealous reformers.

The period between 1800 and 1830 was one of tremendous religious ferment, revival and reform, especially in Connecticut. With the Puritan and Anglican elite's loss of power created by the move to disestablishing religion, along with growing secularism, new denominations moved in to take advantage of the new religious tolerance. The Baptists and Methodists, with their evangelistic tendencies, were readymade for the growing pressure to reform a society that was beginning to feel the excesses of the Industrial Revolution. Utopian communities and experimental societies flourished during this period. Less radical reform movements directed at specific areas of society developed and grew strong, helped by the zealous encouragement of the circuit-riding clergy of these new denominations. These new reform movements included education, temperance societies, societies for the improved treatment of the insane, societies opposing child labor and favoring the equal treatment of women. The most vocal of these were the reform groups demanding the immediate abolition of slavery.

The more conservative elements of society resisted the radicalism of the new religions and considered the circuit-riding clergy a group of meddlesome outsiders who rode into town, preached passionately of the need for reform and rode off with little regard for the community they had just stirred up. Not only were they disconnected from local problems and concerns, which in the case of slavery had already been dealt with, but they were also advocating a crusade against people and problems located in far distant areas to the south.

Abolition did, however, have strong supporters in central Fairfield County, and although their numbers were small, they managed to create considerable resistance to their movement, sometimes to the point of violence. Clear statements of this resistance can be seen in the reporting of the abolitionist newspaper *Charter Oak*, which was published in Hartford from the late 1830s to the Civil War. It reported on the affairs and meetings of all of their regional anti-slave societies, including the one in Fairfield County. In 1839, the account of their July monthly meeting reported that they met "in Huntington…at the house of John Thompson. It was expected that the meeting would be in the Town House which had been open for meetings of all denominations heretofore. When we came to the house, we found it locked and well secured with nails (the Selectmen having had a meeting the night previous)."

Resistance often came from the established clergy. In the same report, the society's secretary explained that the audience for their monthly meeting was "not as large as expected, many not knowing of the meeting. Notice of it was read in but one church in Huntington, and that by a lay-member. Our ministers both refused to read them to their congregations, or even to take any notice of us." The resistance to abolition did not just come from the clergy, but it was also breed by the general lethargy among most of the county's residents for the cause of abolition. By July of 1842, the secretary of the Fairfield County Society was making the following excuses for the light turn at another meeting in Darien:

> *In consequence of the rain in the morning, few of the friends from the neighboring towns were present. As elsewhere not many of the people in Darien, cared enough for the slave to come together to listen to the story of his wrongs, or, in other words, to hear the subject of slavery discussed. Very few of the professed people of God, except open and avowed Abolitionists, are ready even to meet and pray for his emancipation.*

In announcing the details of the next meeting, the secretary pleaded that "we earnestly desire all the friends of the cause in this county, to come up

to this meeting, and let it be seen that Abolition is not dead in old Fairfield County." Apparently his plea fell on deaf ears, because by 1846 reports from Fairfield County had become extremely rare and when they did appear they were only a few lines. The county was not a hotbed of abolition, but that did not mean that the citizens of the county's towns could not be aroused into a fine fervor at times. This fervor was usually stimulated in opposition to aggressive preachers of abolition, as was the case for Reverend Nathaniel Colver and the Georgetown Baptist Church.

Georgetown and the Baptist Church

Surprisingly, Georgetown was a small pocket of social reform sentiment. This was due in great part to the paternalism of the founders of the Gilbert and Bennett wire mill, which was the village's principal employer. That paternalism permeated the entire nineteenth and early twentieth centuries of the firm, but in the 1830s it was especially apparent in the activities of Sturgis Bennett, son-in-law of Benjamin Gilbert. Throughout its early years of publication, Bennett is always mentioned as the agent for the *Charter Oak* newspaper. He is also frequently mentioned as a contributor to the State Central Committee of the Connecticut Antislavery Society along with Benjamin Gilbert, William Gilbert and Samuel Main, who later achieved prominence in anti-slavery circles. Also frequently mentioned was William Wakeman, who lived just south of Georgetown in Wilton, and who became an important figure in the Underground Railroad.

Both Bennett and Main became strong supporters of the Reverend William Stillwell when, in 1921, he broke from the orthodox Methodist Episcopal Church in Georgetown to form a small evangelical sect popularly called the "Stillwellites." They were passionately devoted to several reform causes including temperance; opposition to smuggling; not using weapons of war to deprive people of their rights, life, liberty or property; avoiding usury; avoiding luxurious fashions; and opposition to the slave trade. Stillwell himself was directly involved in the establishment of the African Methodist Episcopal Zion Church in New York and his abolition sympathies permeated his church work and were shared by his followers. By 1829, he turned to devote most of his energies to his New York parishioners and the Georgetown church, with all of its abolitionist proclivities, became the Methodist Protestant Church.

More radical in its abolition sentiments was the Georgetown Baptist Church. The Baptists had maintained a presence in Redding since at least 1785, and by 1833 they had built a small church in the center of

Georgetown. Here gathered warm abolitionists such as William Wakeman and David Chichester, residents of the Cannondale section of Wilton, just south of Georgetown.

It was here in November of 1838 that the church played host to two itinerant and zealous anti-slavery preachers, Dr. Erasmus Hudson and Reverend Nathaniel Colver. Both men, as agents for the Connecticut Anti-Slavery Society, had been on a tour of the state stirring up emotions against slavery, which in turn generated strong opposition to their cause and to them personally. In October they entered Fairfield County lecturing at Sherman, Danbury, Redding, Georgetown and Norwalk, in all cases creating mobs that threatened them with various types of violence, often enforcing their threats with stones and other projectiles. In Bethel, Colver was warned that his appearance would cause a riot, at which he replied that he would deliver his lecture "at all hazards." In Norwalk, the two men were greeted with their own burning effigies and in Danbury Hudson was met with a mob that entered the Baptist Church where he was speaking, smashed the windows and injured some of his audience. With this as a preface, Colver entered Georgetown on November 26 to deliver a major keynote address at the anti-slavery convention that was being held there.

The meeting of November 26 was adjourned prematurely as the pro-slavery crowd outside became increasingly loud and hostile. The next night another attempt to speak was made but the crowd had grown even more violent. The *Norwalk Hour* reported that "a mob composed of men and boys, some with painted faces and some wearing masks, surrounded the church and assailed it with stones, clubs and hideous outcries."[34] During the third night, Colver fearlessly and foolishly delivered an acidic lecture in which he not only excoriated slave sympathizers, but also managed to slander the vice president of the United States, accusing him of having intimate relations with his female slaves.

The climax came at two o'clock the next morning. The residents of Georgetown were awakened by a horrendous explosion. A keg of gunpowder had been placed beneath the pulpit, and when it was set off it managed to destroy the interior of the church, blow off the front of the building and shatter all of the windows. The structural damage was extensive and although the congregation managed to rebuild the church, it never recovered its former energy and by 1847 they voted themselves out of existence.

This was not the end of the violence, however. The abolitionists continued to meet at the house of David Chichester and it was here that they formed the first Georgetown Anti-Slavery society on December 4, with

William Wakeman as its secretary. Retaliation occurred on December 18 when unknown agents placed a bomb against the side of the Chichester residence and with its detonation, blew out all of the windows on that side of the building. For good measure, they also shaved off the tail on Dr. Hudson's horse.

The Underground Railroad

It is not surprising that with all of the abolitionist sentiment in Georgetown, there were active stations on the Underground Railroad operating in that area. The Underground Railroad was a shadowy complex of anti-slavery sympathizers who formed a network dedicated to passing fugitive slaves from one operator to another in a generally northward direction until they could be passed across the Canadian border, where there was no fugitive slave extradition. Since its activities were generally illegal, being made so by the various fugitive slave laws extending from 1793 to the major one of 1850, its operators and the site of fugitive slave concealment were secret and thus generally unknown. It is known that the first Underground operations began in New Haven around 1820. If slaves could flee into the harbor, brought there by sympathetic ship captains trading with Southern ports, they could expect help from the city's large black population, which supplied many willing conductors and station agents. From New Haven, the network spread throughout the state, but it is unclear exactly how it spread and how quickly.

The remarkable scholarship of Horatio T. Strother, however, has uncovered reliable evidence of some Underground operations in the western central part of the county, and recent research has supplied evidence of at least two sites unknown to him.[35] According to Strother, the route into the county came from Westchester across the border and into Greenwich. Fugitives would then proceed up the coast, where there were known stops at Stamford, Darien and Norwalk. From Norwalk they would travel north to Wilton and the home of William Wakeman.

Wakeman was an open and avowed abolitionist. His association with the Georgetown Baptist Church and several of the state's anti-slavery societies is well known. His house still stands on Seely Street and has several reminders of its history with the Underground Railroad, including a trap door under a rug in the present living room that gave access to the basement and a tunnel that originally ran about fifty feet into the backyard, allowing fugitives to escape if necessary. Although the tunnel is no longer intact, about twenty feet of it are still present and accessible from the basement.

Wakeman was both a stationmaster and conductor. According to his contemporaries, when the neighbors saw him and his wife bringing wood and food to an outside guest room, it was assumed that black passengers had arrived. He not only put fugitives up but also frequently conveyed them to the next stop personally. He was known to frequently carry "Hardware and Dry Goods" in his wagon to Plymouth and Middletown, a distance of fifty or sixty miles. It is possible that he also made stops in Waterbury, and since New Milford was a well-known center of the Underground Railroad, it is quite probable that he traveled there as well. He did this openly, often during the daylight, and although he was frequently threatened he was never physically attacked or harmed.

The Wilton station was active from the 1830s until 1847, when Wakeman sold his house and moved to East Haddam. There were undoubtedly others in Wilton who filled in the vacuum that he left, but they were much more clandestine and remain unknown. It is known that about this same time Samuel Main, who was living in Georgetown, was serving as a stationmaster. The proof of this is circumstantial. He was a known abolitionist connected with the Stillwellites and later the Methodist Protestant Church, both notorious as centers of reform activities and liberal attitudes. There is also a wonderful statement of his sympathies in his 1891 obituary in the annual report of the Fairfield County Historical Society, of which he was a founder. He is described as "a strong anti-Slavery man, to whom the fugitive could safely turn for aid and comfort."

Another probable stop on the Underground Railroad has just recently been located in Weston. Although rumors have long circulated about the property now owned by Ellen Strauss on Ladder Hill Road, the icehouse in which fugitive slaves were reputed to have been hidden has just recently come under serious scrutiny when it became the subject of an archaeological field school conducted by Jerry Sawyer of Central Connecticut State College. The icehouse has a well-preserved small tunnel that extends from the base of the east wall eastward for twenty or thirty feet before turning to the north and running another similar distance. There were signs of a door that once closed off this northern branch of the tunnel and a good deal of crockery was found there, some of which had been purposefully inserted into the interstices of the tunnel's rock walls. This Mr. Sawyer identifies as a common form of greeting or identification amongst Africans and it is a feature that appears in other slave sites. The icehouse is certainly an ideal place to secret a fugitive. With blocks of ice and sawdust pushed against the opening in the east wall, it would be impossible to detect someone hiding there.

Abolition and the Underground Railroad:
Blacks and Local Folklore

The historical background reinforces the archaeological evidence. The house to which the icehouse belonged was the homestead of Aaron Buckley, who lived there until his death in 1864. According to depositions that were taken when his estate was finally probated in 1878, he was incompetent during much of the later part of his life. In the words of the deposition he became a "religious monomaniac" and an extremely devout moralist. He was also a member of the Georgetown Baptist Church, which was located a relatively short drive northwest of his home. Here was the perfect candidate for an operative on the Underground Railroad. Unfortunately, to date there is no concrete documentation and proof of the presence of fugitives in the icehouse remains strongly circumstantial.

Local Folklore and Purdy of Purdy Station

There are reputed to be many other stops on the Underground Railroad in the central Fairfield County area, but these are mostly part of this area's rich local folklore. Local folklore is as common as local history and is often mistaken for it. It consists of those stories, often containing a kernel of truth, which are popularly told and retold until they become entertaining and often humorous, but which deviate considerably from historical truth. These stories, because of their delightful nature, are frequently included in local histories, where they take on the authority of historical fact. This is especially true when that local history is compiled by amateur historians.

The tendency to generate folklore is especially strong when dealing with slaves and free blacks, and the Underground Railroad is a favorite subject because of its very nature. The heroic efforts of abolitionists to get slaves out of bondage and into freedom have the type of satisfying, good-against-evil theme that makes excellent folk stories.

In central Fairfield County, as in most of the state, any house that predates the Civil War and has any sort of hidden recess in the basement or attic becomes a station on the Underground Railroad. Countless houses in this area are rumored to have long tunnels emanating from the basement, running under the yard and surfacing in an adjoining field, giving fugitive slaves an opportunity to escape when the inevitable bounty hunters arrived to ferret them out. When these claims are examined, however, the recesses are rarely found, have been blocked up with fieldstones that are suspiciously like the rest of the foundation or have collapsed. Likewise, the escape tunnels never seem to be intact, and the entrance to the collapsed tunnel is difficult to discern among the other stones in the basement walls. Regardless of how strongly local romantics would like to find the hiding places of runaway slaves in their

town's antebellum houses, historic scholarship indicates that the Underground Railroad either bypassed most of central Fairfield County or passed through it without stopping in hopes of quickly getting as far north as possible.

Within Newtown, besides the claims of several house owners whose dwellings were reputed stops on the Underground Railroad, there is also a man who has become a famous stationmaster: Purdy, who manned the so-called Purdy Station. The Purdy legend actually begins outside of the Underground Railroad folklore. According to several sources a smallpox epidemic raged through the area of Hattertown in the late 1850s. It was confined to five or six families that lived along the Monroe Turnpike (now Hattertown Road) near the intersection with Mount Nebo Road. The disease was brought into the area by a family member who had contracted it while in New York. Ultimately it wiped out all those who were exposed it. The town responded by voting to establish a "pest house" where the victims of the rapidly spreading disease could be tended.

A black shepherd named James Purdy had survived the disease and thus was rendered immune to it. While the pestilence was at its height, Purdy offered to take care of the sick and dying at his small shack at the end of a short access road. A local member of the Parmalee family, who was a carpenter, arranged to supply coffins for the dead, but since he had not had the disease, he would go no closer to Purdy's residence than the end of Mount Nebo Road, where he left the coffins to be picked up at Purdy's convenience.

According to one of the less complimentary versions of this story, Purdy sold the coffins and pocketed the money while burying the smallpox victims in shallow graves near the Redding border, wrapped in nothing more than a thin shroud. Kinder versions have Purdy burying the unfortunates using Parmalee's coffins in the Hopewell Cemetery because it was the farthest out of town of any of Newtown's cemeteries. In this version he is assisted by another unknown black man who was also a smallpox survivor.

Many variations of the Purdy story include his position as a stationmaster on the Underground Railroad. Since the area was pestilential, his house was a perfect safe house for escaped slaves, since bounty hunters and snooping neighbors would obviously stay clear of it. Nowhere does it say how fugitive slaves, who were not immune to the disease, felt about being hidden in a smallpox-ridden house.

Purdy's heroic efforts have been commemorated by naming the short access road on which he is reputed to have lived Purdy Station Road. But the account of this story that appears in the various editions of the League of Women Voters history of Newtown concludes, "It would seem that the town might have bestowed some greater official recognition upon one who

so nobly embodied the highest ideal of Christianity."[36] Some slight official recognition was given to Purdy in 1976 during the nation's bicentennial, when his name was prominently placed in the summary history of the town, inscribed on the aluminum sign at the northeast corner of the Edmond Town Hall.

Several elements of this folk legend can be quickly stripped away and discarded as untrue. The Underground Railroad motif can be dispensed with first, since there is no documentation that the slave-saving operation functioned anywhere in Newtown. The scope and magnitude of the smallpox epidemic required a little more research. According to Henry Beer's bill of mortality and the town's vital records, there were only three smallpox deaths in 1859, all of the same family and all of whom died in December of that year. In addition there was one other smallpox death, which occurred on January 1, 1860. There were no other smallpox deaths in the decades preceding or following these deaths. It would appear the smallpox epidemic was small indeed.

Even though the outbreak was small, town officials were not oblivious to the danger posed by the outbreak of the disease. A special town meeting was called for December 29, 1859, after the three members of the Whitlock family died. The warning for that meeting claimed that it was to consider "adopting such measures as may be deemed efficient to arrest the spread of contagious disease in said town possibly involving, among other measures, the erection of a pest house, and the purchase of land for that object, and to indemnify the keeper of the town poor against extraordinary expenses arising out of the existing prevalence of smallpox in said town." Apparently the threat was not considered very great, since the motion for a pest house was never even brought to a vote. In fact, the only outcome of that special meeting was a vote to pay the "doctors and nurses fees for treatment of smallpox contracted by the town poor." These payments never had to be made.

Another feature of the Purdy legend that does not survive a little research is the location of the outbreak. The residences of the smallpox victims do not appear on any of the several maps of Newtown for the 1850s. Newtown's vital records give one of the victim's occupations as a rubber worker, which would indicate that he must have lived near the rubber factory in the Glen. A search of the index of headstone inscriptions for Newtown cemeteries places the burial of all the victims in the Sandy Hook cemetery. It would appear, then, that our epidemic was confined to Sandy Hook, not Hattertown.

Even the existence of Purdy himself is suspect, although there are some scattered records suggesting that a man by that name was living in Newtown.

He is mentioned twice in the vital records: first on December 20, 1835, when he married Caroline Green of Bridgeport; and second on April 19, 1859, during the year of the so-called smallpox epidemic, when his wife, now given as Fanny, gave birth to a male child. In both of these records his age indicates that he was born in 1814, although it is not known where that birth took place. He is also listed as a laborer.

The only other record of his existence in Newtown is the census of 1850. He is listed as Family #179, consisting of himself, age thirty-five; his wife, now named Elvira; and a son, George H., born in 1839, about four years after Purdy's marriage to Caroline. His three wives pose a dilemma that will probably never be resolved. It is unlikely that there would have been three or even two men named James Purdy who were black laborers and born in the same year. All three of these records must refer to the same man. It is possible that Caroline died and that Purdy remarried, but did his second wife die as well, allowing him to marry for a third time? There are no marriage records for either Elvira or Fanny. Was he even married to Elvira in the 1850 census? She was three years younger, which made her too old to be a daughter, but since there is no relation given for any of the census entries, the possibility that they were not actually married is a real one.

The census record gives one other clue to Purdy's residence. He is listed as family #179 living in dwelling #165, but he is not the only family living in that house. The other residents were Betsey Gilbert, age thirty-five, and her daughter Fanny, age twelve, both white. The living arrangement appears to be that of a hired hand, Purdy, who was employed and given room and board for helping widow Gilbert and her daughter make a living on their land holdings. The residence of Betsey Gilbert cannot be found on any of the maps of the period, but several of her neighbors are listed in the census table. William Platt, Fairchild McLane, Oliver Peck and Harriet Beers are known to have lived on or near the Bridgeport-Newtown Turnpike (modern Route 25) in the Botsford section of town (near the present Sand Hill Plaza). This is far from Purdy Station Road, located in the western part of town, although in the nine years between the census and the outbreak of smallpox it is possible that he moved into the area of Purdy Station. Farm laborers experienced a high degree of mobility and frequent changes of residence were common as labor demands shifted within the town.

What, then, is left of the Purdy story that may be historically accurate? We know that he was a black farm laborer who probably lived in Newtown for at least twenty-five years between 1835, when he was first married, and 1859, when his son was born. During part of that time he lived in the south central part of the town, but beyond this, we know little more. He is not in the 1860 census and appears to have left town by then. A search of the

state records has failed to turn up any further mention of him, so he either died in Newtown in 1860 without leaving any record or he moved out of the state entirely.

We also know there was a smallpox outbreak in the Sandy Hook area, but it did not reach epidemic proportions. There was sufficient concern on the part of the townspeople, however, to consider erecting a pest house to contain the contagion, but that concern did not extend to taking any action beyond voting to allocate funds to pay the doctors' bills for the town's poor, an allocation that never had to be acted upon.

Gradually, over the next century, these facts were woven together until they grew into the story of altruism that became part of the town's oral history, or more correctly, oral folklore. Somewhere during this same period, the story of the Underground Railroad operating in Newtown became grafted onto the smallpox story, enlarging Purdy's heroism. Then, in 1955, the League of Women Voters published a brief history and guide to Newtown in which the story was written down for the first time. This volume was rewritten and republished in 1975 with the Purdy story included and unchanged. There was yet a third edition of the work published in 1989 with the guide portion deleted. It is now a history of Newtown and the Purdy story is there with only minor changes. Purdy, Purdy Station and the Underground Railroad have now become "history."

Appendix

The Slaves of
Central Fairfield County

*B*elow is a brief catalogue of the slaves of central Fairfield County. This list constitutes all of the slaves for which records of any sort could be found. By our best estimates this list contains less than half of those who were slaves within the towns of Newtown, Redding, Easton and Weston. Every effort has been made to identify and separate slaves of the same name, but some duplication undoubtedly still occurs, especially where a slave had more than one master, and there is no way to establish that they are the same person because of scanty and incomplete records. Some slaves are only known from the briefest contemporary mention of their name and owner.

Newtown

Last Name	First Name	Master	Born/ Baptised	Freed	Died
	Alexander	Nathaniel Briscoe	1767		February 16, 1812
	Asael	Matthew Curtiss	July 5, 1747		
	Boston	Elijah Nichols	June 1769	October 6, 1801	May 21, 1825
Hill	Candace	Benjamin Curtis, then Stephen Crofut	1773	January 14, 1794	June 3, 1808
	Candace	Philo Norton	circa 1778	ran off 1798	

Last Name	First Name	Master	Born/ Baptised	Freed	Died
Platt	Cato	Moses Platt	1742	before 1784	January 9, 1828
Freeman (Hard)	Cesar	Cyrenius Hard	1781	August 3, 1812	January 7, 1830
	Dinah	Reuben Booth			April 6, 1808
	Dinah	Elijah Nichols	1773	April 18, 1803	
	Dinah	Moses Platt	1752		June 30, 1774
Booth	Dorcas	Jonathan Booth	January 27, 1783		
	Dorcas	John Lott, then David Beers	1770	November 11, 1799	
	Ellik	Nathaniel Brisco			
	Flora	Daniel Morris Jr.			
	Gander	Nathaniel Brisco			
	Gene	Daniel Glover	October 7, 1787	eligible 1812	
Platt	Gilbert	Jarvis Platt	1775	October 10, 1804	
	Happy	Thomas Tousey			
	Jacob	Philo Tousey	September 15, 1754		January 6, 1800
Curtis	Jennie	Caleb Baldwin	August 26, 1782, in Stratford		
	Jenny	Matthew Curtis			
	Jenny	Philo Curtis	1818		
	Jenny	William Edmond	May 11, 1786	due 1811	
	Jenny	Captain John Glover	1731		July 14, 1771
Curtis	Joseph Freedom	Caleb Baldwin	October 27, 1784		May 6, 1790

Last Name	First Name	Master	Born/ Baptised	Freed	Died
Nichols	Juba	Elijah Nichols	February 15, 1796		April 15, 1823
	Julius Cesar	Ebenezer Beers		July 30, 1796	
Peters	Lemuel	Ezra Booth	1763	November 5, 1795	January 3, 1830
	Leuse	David Judson	circa 1713		January 11, 1763
	Lydia	Jonathan Booth	1755	December 24, 1792	
	Mary	Abner Booth	October 11, 1747		
	Nancy	Nathaniel Briscoe	September 18, 1763		
	Nancy	Daniel Glover			
Bush	Nancy	Solomon Sanford	August 14, 1762	June 18, 1798	June 15, 1804
Turner	Nancy	Ebenezer Turner			December 3, 1806
	Ned	Nathaniel Briscoe	January 3, 1763		
Booth	Ned	Abraham Booth	1755	April 11, 1794	September 6, 1825
Hill	Ned	John and Moss Botsford	1769		October 29, 1806
	Ned	Benjamin Hawley	October 6, 1788	eligible 1813	
	Ned	Lemuel Sherman			
	Peggy	Nathaniel Briscoe	January 19, 1766		
Booth	Peg	Daniel Booth	1771	May 9, 1796	April 14, 1831
	Peg	Moses Platt	1770		
	Peter	Matthew Curtis			
	Peter	Captain John Glover			

Last Name	First Name	Master	Born/ Baptised	Freed	Died
	Peter	Daniel Glover	January 30, 1788	eligible 1813	
Brisco	Philip	Nathaniel Brisco, then Caleb Baldwin	October 25, 1777		April 30, 1798
	Philip	Captain John Glover			
Curtis	Phillis	Caleb Baldwin	February 16, 1762, in Stratford		
	Plato	John Fairchild			January 10, 1772
	Pomp	Matthew Curtiss	November 1759		
	Pricilla	Captain John Glover			
Booth	Prince	Reuben Booth, then Mary Booth	October 1777	December 12, 1803	September 4, 1807
	Rose	Nathaniel Briscoe	September 16, 1764		
	Rose	Phebe Beach	1770	October 10, 1802	
Clark	Rose	Reverend Jehu Clark	January 12, 1791		
	Rose	Daniel Glover	December 3, 1790	eligible 1815	
	Rose	Peter Nichols	June 24, 1774		November 27, 1795
	Rose	Thomas Wheeler			
	Samson	Abel Botsford			
	Seaman	Ebenezer Ford	March 1763		April 21, 1765

Last Name	First Name	Master	Born/ Baptised	Freed	Died
Booth	Susanna (Sue)	Reuben Booth, then Mary, his wife		died a slave	April 30, 1821
	Sylvia	Reverend David Judson			
	Temp	James Glover	June 27, 1771		January 7, 1799
	Temp	Reverend David Judson			
	Time	Sarah Nichols	circa 1772		December 1, 1815
Curtis	Tobias	Nehemiah Curtis	1760	May 9, 1791	September 5, 1825
	Venus	Abner Booth	October 2, 1743		
	Zad	Nathaniel Briscoe	May 30, 1773		
Booth	Zephaniah	Daniel Booth		May 9, 1796	

Redding

Last Name	First Name	Master	Born/ Baptised	Freed	Died
	Aaris	Isaac Gorham	January 1, 1787		
	Amos	Isaac Gorham			
	Amon	Stephen Betts	September 17, 1793		
	Ana	William Hill	December 27, 1784		
	Andrew	John Read	June 26, 1736		
	Andrew	Samuel Sanford	January 25, 1734		

Last Name	First Name	Master	Born/ Baptised	Freed	Died
	Caesar	Ephraim Sanford	January 25, 1734		
	Caesar	Samuel Smith	May 23, 1767		
	Cato	Reverend Nathaniel Hunn	April 13, 1740		
	Cesar	Ephraim Jackson			
	Damaris	John Read	February 19, 1751		
	Daniel	John Read	March 3, 1747		
	Dinah	Samuel Smith	January 29, 1779		
	Dinah	Samuel Smith	1808		
	Dorcas	Aaron Sanford	June 26, 1797		
	Fillis	Thomas Couch	January 18, 1797		
	Genny	Stephen Betts			
	Harry	Aaron Sanford	April 23, 1803		
	Harry	William Hawley	December 1, 1785		
	Heiress	Isaac Gorham			
	Henry	Jas Rogers, esquire	May 15, 1807		
	Jack	Mr. Sturgis	1730		
	Jack	Simon Couch	January 28, 1785		
	Jone	Isaac Gorham	April 11, 1772		
	Kate	John Read	June 26, 1736		
	Mill	John Read	1767		
	Nan (Simon's mother)	William Hawley			

Last Name	First Name	Master	Born/ Baptised	Freed	Died
	Nanne	Benjamin Darling	circa 1746		February 25, 1761
	Nancy	Aaron Sanford	October 18, 1800		
	Nanny	Joseph Banks	February 12, 1775		
	Nanny	Stephen Burr			
	Ned	Isaac Gorham	March 29, 1794		
	Ned	Samuel Smith	February 6, 1755		April 27, 1777
	Ned	Ashel Fitch	September 15, 1785		
	Ninzio	Joseph Banks	February 12, 1775		
	Parrow	Deacon Stephen Burr	April 4, 1736		December 25, 1771
	Patience (Anna and Rhoda's mother)	William Hill			
	Peg	Samuel Smith	September 19, 1773		
	Peter	Thaddeus Benedict			
	Peter	William Hawley	August 6, 1788		
	Peter	Zalmon Read	March 1749		
	Philip	John Read	June 26, 1736		
	Phillis	Simon Couch	September 8, 1793		
	Phylis	Benjamin Darling	circa 1750		May 1, 1761
	Phylis (Nancy and Harry's mother)	Aaron Sanford			

Last Name	First Name	Master	Born/ Baptised	Freed	Died
	Pomp	Hezekiah Sanford	circa 1782	April 1, 1807	
	Prime	Nathaniel Barlow			
	Primus	Isaac Gorham			
	Rhoda	William Hill	January 9, 1788		
	Robbin	John Hull	July 29, 1733		
	Sabrena	Deacon Stephen Burr	June 18, 1742		
	Simon	William Hawley	April 9, 1791		
	Simon	John Read	January 19, 1753		
	Solomon	John Read			
	Tamar	Joseph Banks	February 12, 1775		
	Tamar	Isaac Gorham			
	Thomas	Stephen Morehouse			
	Thomas	John Read	June 26, 1736		
	Titus	John Read	October 4, 1739		
	Venus	Simon Couch	January 30, 1768		January 30, 1768
	Will	Isaac Gorham			
	York	Joseph Sanford	April 27, 1735		
	Ziphora (Fillis's mother)	Thomas Couch			

Easton and Weston

Last Name	First Name	Master	Born/ Baptised	Freed	Died
	Amos	Morehouse Coley	circa 1783	June 19, 1812	February 28, 1848
	Asher	Ebenezer Coley		February 7, 1810	
	Caesar	Isaac Godfrey	December 3, 1792		
	Ceser	Samuel Wakeman	circa 1742		
	Caty	Ebenezer Coley	November 1795		
	Charles	Samuel Wakeman	October 1, 1798		
	Cloe	Ebenezer Coley	April 1790		
	Enoch	Josiah Sanford	circa 1764		
	Hannah	Samuel Wakeman	June 14, 1784		
	Harry	Samuel Wakeman	August 29, 1792		
	Ismael	Ebenezer Coley	1778		
	Jack	Ebenezer Coley	March 1794		
	Jack	Samuel Wakeman	circa 1752	April 10, 1797	
	Nancy	Ebenezer Coley	December 5, 1798		
	Nancy	Samuel Wakeman	December 5, 1795		
	Ned	David Bradley	July 4, 1773	August 7, 1804	
	Ned	Reverend John Noyes		December 17, 1801	
	Nelly	Samuel Wakeman	June 14, 1784		
	Peter	Morehouse Coley	1790	June 19, 1812	

Last Name	First Name	Master	Born/ Baptised	Freed	Died
	Philip	Nathaniel Seeley		April 8, 1799	
	Philip	Daniel Glover		April 19, 1798	
	Phillis	Samuel Wakeman		April 10, 1797	
	Phillis	Samuel Wakeman	January 9, 1790		
	Pomp	Ebenezer Coley	1785		
	Primus	Samuel Wakeman	July 12, 1788		
	Quamano (Quam)	Seth Smith		June 26, 1807	
	Simon	Ebenezer Coley	September 1791		
	Titus	Zachariah Lyon	June 19, 1788		
	Tom	Daniel Glover		April 13, 1801	

Notes

The intent of these notes is to provide the reader with sources of historical information or interpretation that are controversial or of sufficient interest that the reader might wish to pursue them. Not included here are the numerous references to town, church and state records. It was felt that such references would unnecessarily burden the text with notes. In text references to the relevant records have been used wherever statistical or factual material has been mentioned that has come from these standard sources. Checking on these statistics and facts can easily be done by consulting the relevant indices for the cited records.

Chapter 1

1. All of these cases are cited in *The Public Records of the State of Connecticut*, Vols. 7–9. See index under slaves. [Note: all subsequent references to state legislation are taken from the relevant volumes of this series unless otherwise noted.]
2. Charles Burr Todd, *The History of Redding Connecticut* (New York: The Grafton Press, 1906), 132.
3. Ibid.

Chapter 2

4. The various pre-1790 censuses can be found as appendices in Hammond Trumbull's *The Public Records of the Colony of Connecticut, Vol. 1* (Hartford: Brown & Parsons, 1850).
5. Robert K. Fitts, "The Landscapes of Northern Bondage," *Historical Archaeology* 30, no. 2 (1996): 54–73.
6. Tom Gidwitz, "Freeing Captive History," *Archaeology Magazine* 58, no. 2 (2005): 31–35.
7. Robert William Fogel and Stanley L. Engerman, *Time on The Cross: The Economics of American Slavery* (Boston: Little, Brown, and Co., 1974), 49–50.

8. Jerry Sawyer and Kathleen von Jena, personal communication.

9. Philip Burnham, "Selling Poor Steven: The Struggles and Torments of a Forgotten Class in Antebellum America; Black Slaveowners," *American Heritage* (February–March 1993): 91–97.

10. The designation £/s for pounds sterling and shillings, rather than £:s, is being used here since that is the way it appears in most colonial probate and accounting documents.

11. Vincent J. Rosivach, "Slavery in Fairfield at the End of the Colonial Period," paper delivered to the Fairfield Historical Society, October 20, 1992. Manuscript in the collections of the Fairfield Historical Society.

12. Judge Martin H. Smith, "Reminiscence of Old Negro Slavery Days in Connecticut," *The Connecticut Magazine* 9, no. 1 (1905): 145–53.

13. The ad excerpted here was taken from the *American Telegraph and Fairfield County Gazette*, November 5, 1798. It was reprinted in the *Newtown Bee*, April 1, 1910, having been discovered by Ezra Johnson along with a number of other items of local interest extracted from the same source.

Chapter 3

14. Fogel and Engerman, *Time on The Cross*, 40.

15. Ibid., 148.

16. Orville H. Platt, "Negro Governors," in *Papers of the New Haven Colony Historical Society, Vol. VI* (New Haven, 1900), 315–35.

17. These men may have been justices of the peace but had not used their title when recording the marriage in the town's vital records.

18. Lorenzo Johnston Greene, *The Negro in Colonial New England* (New York: Atheneum, 1971), 272.

Chapter 4

19. There was a fourth child who died on April 23, 1800, but there is nothing known about this child, not even its sex.

Chapter 5

20. James Deetz, *In Small Things Forgotten: An Archaeology of Early American Life* (New York: Anchor Doubleday, 1996), 202.

21. Leland Ferguson, *Uncommon Ground: Archaeology and Early African America, 1650–1800* (Washington: Smithsonian Institution Press, 1992), 110.

22. Robert Ferris Thompson, *Flashes of the Spirit: African and Afro-American Art and Philosophy* (New York: Random House, 1983), 108.

23. June Swann, "Shoes Concealed in Buildings," *Journal 6* Northampton Museums and Art Gallery (December 8–21, 1969): 8.

Chapter 6

24. Elizabeth H. Schenck, "History of Fairfield, Vol. II" (New York: self-published, 1905), 385.

25. David O. White, *Connecticut's Black Soldiers, 1775–1783* (Chester: Pequot Press, 1973), 56.

26. Winthrop D. Jordan, "Enslavement of Negros in America to 1700," in *Colonial America*, ed. Stanley N. Katz (Boston: Little, Brown, and Co., 1971), 383–84; J. Hammond Trumbull, *The Public Records of the Colony of Connecticut, Vol. 1* (Hartford: Brown & Parsons, 1850), 349.

27. White, *Connecticut's Black Soldiers*, 15.

28. E. Merrill Beach, *From Valley Forge to Freedom: A Story of a Black Patriot* (Trumbull: Connecticut Bicentennial Commission, 1975).

29. Archibald Robinson, *His Diaries and Sketches in America, 1767–1780* (New York: New York Public Library, 1930), 127.

30. Robert McDevitt, *Connecticut Attacked: A British Viewpoint, Tryon's Raid on Danbury* (Chester, CT: Pequot Press, 1974), 37.

31. Ibid., 38.

32. *Revolutionary Lists and Returns, Connecticut Line, 1777–1781, Vol. 12,* (Hartford: Collections of the Connecticut Historical Society), 124.

33. For a detailed account of the Sheep Company, see Jane Eliza Johnson, ed., *Newtown's History and Historian* (Newtown, CT, 1917), 180–88.

Chapter 7

34. Erik Linstrum, "'High-Handed Outrage': The Slavery Debate Explodes in Connecticut," *The Concord Review* 11, no. 3 (Spring 2001): 49–58.

35. For a well-researched account of the operation of the Underground Railroad in this area and in Connecticut in general, see Horatio T. Strother, *The Underground Railroad in Connecticut* (Middletown, CT: Wesleyan University Press, 1962).

36. League of Women Voters, *Newtown Connecticut: Past and Present* (1975), 40. See also the 1955 edition, 4.

Sources

Primary Sources

TOWN OF NEWTOWN

Land records.
Probate records. (Until 1820, the Newtown probate records were archived in the Danbury probate office. After 1820 they were located in the Newtown probate office.)
Tax lists, 1806–35.
Vital records (births, marriages and deaths).

CHURCH RECORDS

The Congregational Church of Newtown.
The Methodist Church of Newtown.
Trinity Episcopal Church.

STATE RECORDS

Census records, 1790–1860. (These are actually federal records. Microfilm copies of these records were consulted at the State Library and at Cyrenius H. Booth Library in Newtown.)
Headstone inscriptions, town of Newtown, Connecticut. (Compiled in 1934. There is a copy of this record in the Cyrenius H. Booth Library.)
Vital records of other Connecticut towns.

Sources

Private Records

Account books, collections of the Newtown Historical Society.
Bill of mortality, kept by Henry Beers for the years 1797 and 1863. (Original is in the Cyrenius H. Booth Library collections.)
Miscellaneous documents, Cyrenius H. Booth Library collections.

Published Sources

Acts and Laws of the State of Connecticut in America. New London, CT: Timothy Green, 1784.

Beach, E. Merrill. *From Valley Forge to Freedom: A Story of a Black Patriot.* Trumbull: Connecticut Bicentennial Commission, 1975.

Burnham, Philip. "Selling Poor Steven: The Struggles and Torments of a Forgotten Class in Antebellum America; Black Slaveowners." *American Heritage* (February–March 1993): 91–97.

Deetz, James. *In Small Things Forgotten: An Archaeology of Early American Life.* New York: Anchor Doubleday, 1996.

Ferguson, Leland. *Uncommon Ground: Archaeology and Early African America, 1650–1800.* Washington, D.C.: Smithsonian Institution Press, 1992

Fitts, Robert K. "The Landscapes of Northern Bondage." *Historical Archaeology* 30 (1996): 54–73.

Fogel, Robert William, and Stanley L. Engerman. *Time on The Cross: The Economics of American Slavery.* Boston: Little, Brown, and Co., 1974.

Gidwitz, Tom. "Freeing Captive History." *Archaeology Magazine* 58, no. 2 (2005): 31–35.

Greene, Lorenzo Johnston. *The Negro in Colonial New England.* New York: Atheneum, 1971.

Johnson, Jane Eliza, ed. "Newtown's History and Historian." Newtown, CT: self-published, 1917.

Jordan, Winthrop D. "Enslavement of Negros in America to 1700." In *Colonial America*, edited by Stanley N. Katz, 363–404. Boston: Little, Brown, and Co., 1971.

Labaree, Leonard Woods. "Introduction." In *The Public Records of the State of Connecticut, Vol. VIII*, xvii–xx. Hartford: Connecticut State Library, 1951.

League of Women Voters. *Newtown*. 1955. Republished in a second edition titled *Newtown Connecticut: Past and Present*, 1975. A third edition, retitled *Newtown Connecticut: Directions and Images*, was published in 1989.

Linstrum, Erik. "'High-Handed Outrage': The Slavery Debate Explodes in Connecticut." *The Concord Review* 11, no. 3 (Spring 2001): 49–58.

McDevitt, Robert. *Connecticut Attacked: A British Viewpoint, Tryon's Raid on Danbury*. Chester, CT: Pequot Press, 1974.

Mitchell, Mary H. "Slavery in Connecticut and Especially in New Haven." In *Papers of the New Haven Colony Historical Society, Vol. X*. Tuttle, Morehouse and Taylor: New Haven, 1915.

Platt, Orville H. "Negro Governors." In *Papers of the New Haven Colony Historical Society, Vol. VI*, 315–35. New Haven, 1900.

The Public Statute Laws of the State of Connecticut. Hartford: S.G. Goodrich, & Huntington, & Hopkins, 1821.

Revolutionary Lists and Returns, Connecticut Line 1777–1781. Vol. 12. Hartford: Collections of the Connecticut Historical Society.

Robinson, Archibald. *His Diaries and Sketches in America, 1767–1780*. New York: New York Public Library, 1930.

Rosivach, Vincent J. "Slavery in Fairfield at the End of the Colonial Period." Paper delivered to the Fairfield Historical Society, October 20, 1992. Manuscript in the collections of the Fairfield Historical Society.

Schenck, Elizabeth H. "History of Fairfield, Vol. II." New York: self-published, 1905.

Sources

Smith, Judge Martin H. "Reminiscence of Old Negro Slavery Days in Connecticut." *The Connecticut Magazine* 9, no. 1 (1905): 145–53.

Steiner, Bernard C. *History of Slavery in Connecticut*. Baltimore: Johns Hopkins Press, 1893.

Strother, Horatio T. *The Underground Railroad in Connecticut*. Middletown, CT: Wesleyan University Press, 1962.

Swann, June. "Shoes Concealed in Buildings." *Journal 6* Northampton Museums and Art Gallery (December 8–21, 1969).

Thompson, Robert Ferris. *Flashes of the Spirit: African and Afro-American Art and Philosophy*. New York: Random House, 1983.

Todd, Charles Burr. *The History of Redding Connecticut*. New York: The Grafton Press, 1906.

Trumbull, J. Hammond. *The Public Records of the Colony of Connecticut, Vol 1*. Hartford: Brown & Parsons, 1850.

Warner, Robert Austin. *New Haven Negroes: A Social History*. New York: Arno Press and The New York Times, 1969.

Weld, Ralph Foster. *Slavery in Connecticut*. New Haven: Tercentenary Commission of the State of Connecticut, 1936.

White, David O. *Connecticut's Black Soldiers 1775–1783*. Chester: Pequot Press, 1973.

Visit us at
www.historypress.net